# IMAGES of America
# THE BOOTHBAY REGION REVISITED

Boothbay Region Historical Society

Copyright © 2004 by Boothbay Region Historical Society
ISBN 0-7385-3625-3

First published 2004

Published by Arcadia Publishing,
Charleston SC, Chicago IL, Portsmouth NH, San Francisco CA

Printed in Great Britain

Library of Congress Catalog Card Number: 2004104898

For all general information, contact Arcadia Publishing:
Telephone 843-853-2070
Fax 843-853-0044
E-mail sales@arcadiapublishing.com
For customer service and orders:
Toll-free 1-888-313-2665

Visit us on the Internet at www.arcadiapublishing.com

On the cover: The 180-foot schooner *James E. Newsom* was launched in August 1919 from the East Coast shipyard on the east side of Boothbay Harbor. A cargo vessel, she was sunk by a submarine in 1942.

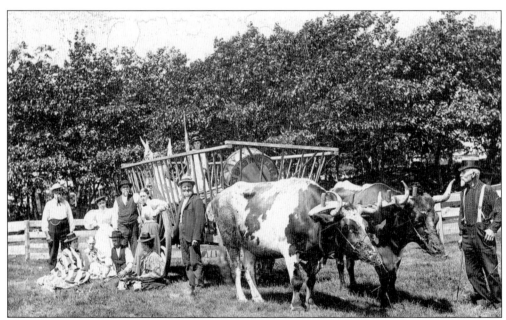

East Boothbay Civil War veteran Dennis Hagan (in the vest) and friends pose after an 1890s Memorial Day parade. The drum of the Grand Army of the Republic Harvey Giles Post No. 157 is in the oxcart, and a woman is wrapped in a flag. Giles was killed at Fredericksburg during the Civil War. The drum is now at the Boothbay Region Historical Society, and the oxcart is at the re-created historical Boothbay Railway Village.

# Contents

| | | |
|---|---|---|
| Acknowledgments | | 6 |
| Introduction | | 7 |
| 1. | The Early Years | 9 |
| 2. | Marine Trades at Sea | 21 |
| 3. | Marine Trades Ashore | 39 |
| 4. | Shipbuilding | 53 |
| 5. | Commerce | 69 |
| 6. | Coming Together | 83 |
| 7. | Summer Communities | 99 |
| 8. | Our Villages | 117 |

# Acknowledgments

This book is a tribute to the hundreds of townspeople who, in the years since the Boothbay Region Historical Society was formed in 1967, have freely given their photographs to the society. Those generous people made this book possible.

Most photographs were taken at momentous or out-of-the-ordinary events, such as parades, fires, outings, and launchings. They outnumber the images of everyday, commonplace activities such as a family picking blueberries—the kind of event that people rarely commemorate. This book tries to depict the broad outlines of both the ordinary and the remarkable in the Boothbay region in an earlier time.

Credit for assembling the book goes to those who volunteered to join the book committee. They took responsibility for chapters, chose photographs to best represent the region, wrote captions, proofread, and edited. Those hard-working volunteers—authors all—are Judy Cook, Doreen Dun, Jim Hunt, Andy Matthews, Faith Meyer, Robert Rice, Cathy Sherrill, Alden Stickney, and Peggy Voight. Special gratitude goes to Alden Stickney for his 20 years of photographic work for the society.

—Barbara Rumsey, Director
Boothbay Region Historical Society

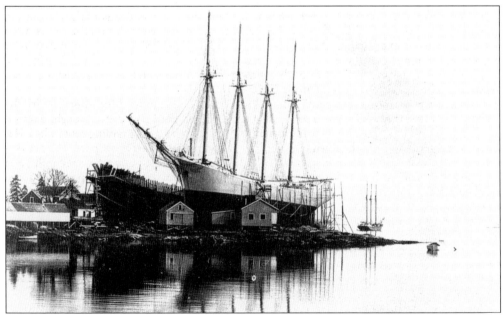

If Boothbay could be said to have a single enduring identity, it would be as a shipbuilding center. Seen here is McFarland's Point in Boothbay Harbor in 1919. Around that time, 100 men worked at the Atlantic Coast shipyard, building mostly four-masters. The 221-foot *Bradford E. Jones* is ready for launching, while the *Mary Bradford Pierce* is framed but has a long way to go.

# INTRODUCTION

Long inhabited by American Indians, the Boothbay area of Maine was visited and settled unsuccessfully by Euramericans during the 1600s. The region was permanently resettled c. 1730 by perhaps 40 Scotch-Irish families who were drawn from New England and Ireland by the developer Col. David Dunbar. He was involved in the power struggle between Massachusetts and Britain and, it was later determined, had settled the area without permission. When Dunbar was removed in disfavor, the settlers were left on a hostile frontier without clear land ownership. Some pioneers hung on, but more American Indian wars and the ownership problem hampered the growth of the area. The vacuum created by lack of legal possession allowed conflicting land claimants to rush in, with consequent misery for the settlers. Opportunistic, competing land sharks dunned the settlers over and over for their land.

The pioneers who stayed and those who joined them principally farmed, fished (as they grew accustomed to coastal conditions), and sold wood—Boston had an insatiable appetite for firewood. The area had a few water-powered sawmills and gristmills, and most parts of town were little commercial centers, each with a mill, a store, and specialized workers such as blacksmiths. Besides the independent village economy, the norm was for each household to be a little factory in itself, providing its own food, heat, and power. This standard held until the Industrial Revolution.

Boothbay was finally incorporated in 1764, thus allowing the townspeople to tax themselves, gain more clout, and carry out projects, such as road building. The outbreak of the Revolution amplified the impoverished character of the area. Men who wanted to defend their town were drafted to defend other parts of the seaboard; in all, more than 100 local men served away or locally. Following the war, the population grew rapidly as the town formed its identity as a community at home on the water through vessel building, fishing, and coasting (carrying goods by water). The population stood at about 1,000 in 1800.

Boothbay's comparative prosperity faltered with the economic hardships imposed by the embargoes of the early 1800s, precursors to the War of 1812. But again, peace brought a return to good times, and the town hit its stride as a fishing, coasting, and shipbuilding center. In 1842, Cape Newagen Island left the town of Boothbay and was soon named Southport. The period's prosperity created more support businesses, including numerous small water-powered mills, and specialized workers such as sailmakers, riggers, and blacksmiths. By 1850, the population had reached 2,500. Vessels were turned out to fish the rich codfish banks of the Gulf of Maine and to carry goods, principally to the southern states, the Caribbean, and South America. By the 1850s, there was a national boom that greatly benefited all the local endeavors, with large vessels—brigs, barks, ships, and schooners—launched one after the other.

The economic crash of 1857 drove many shipyards temporarily under, and the Civil War turned the town's attention again to war and dampened the seagoing routine. More than 250 men enlisted to fight, some of them dying in battle. After the war, the cod-fishing industry never fully recovered, principally because of the withdrawal of a government bounty.

But the Industrial Revolution was upon America, and soon other pursuits provided economic muscle: mackerel fishing grew in popularity, and pogie fishing evolved, as did fishing for sardines and lobsters. Cutting and selling ice from freshwater sources boomed in the 1880s, and soon mammoth buildings sprouted in order to store ice and process fish. Finally, factories arrived in Boothbay. The ice businesses and canneries of all sizes gave the working people of the area many more employment choices for earning hard cash to carry them through the year.

Though Boothbay's population rose to 3,200 by the 1870s, the next 50 years saw no real year-round population growth, as small farms were pinched by "progress" and other locales called people away to cities and the West.

Boothbay's attraction as a summer resort slowly grew in the late 1800s with the Industrial Revolution and the rise of the middle class. The 1880s saw a boom in land values as summer colonies sprang up and steamers were in their heyday for quick transport from Portland and Boston. Though traditional businesses survived, they were outdistanced by the growth of the region as a summer resort. Companions to the summer homes were summer hotels, built to accommodate those who visited as tourists. Support services, such as restaurants, gift shops, and excursion boat rides, grew in importance.

The population expanded by almost one-third to about 3,500 between 1850 and 1880. In 1889, the area now containing Boothbay Harbor left the town of Boothbay. The population slowly continued to increase, but it fell as the modern era—the 1920s and 1930s—arrived with the automobile, mechanization, industrial farming, and the demise of both the village-based economy and the small home-industry model of self-sufficiency. Telegraph, telephone, and electric wires, tarred roads, and water systems slowly spread through the region; by the 1930s, the most populated areas had a modern look. The rise of good, reliable roads caused waterborne passenger and freight traffic to dwindle, a trend much regretted by those who loved the steamers.

The shipyards moved away from the old model of building principally work boats, and they took on war work and yacht building in the 20th century. After mid-century, East Boothbay was the locus for most shipbuilding in the region.

Today Boothbay and Boothbay Harbor have a population of about 6,000. No one knows the true, much larger population, since many who have homes here and live here for many months of the year are residents elsewhere. The tourist industry and lobster fishing are the principal focal points of the local economy, but the town is well diversified in other job opportunities, most of which are service-oriented. Boothbay is a fortunate area with its mix of year-round and summer people; the changing seasons bring changing faces and activities.

## One
# THE EARLY YEARS

This chapter highlights Boothbay region history before the age of local photography. Included are views of significant locations from prehistoric American Indian habitation to the 1860s.

We start with the most ancient human settlements, for there is evidence that people have been in Boothbay for about 10,000 years. In the 1600s, most Euramericans visited with short-term economic goals: to fish, trap, cut wood, and carry those products away. The first tentative English sites were the early 1600s fishing stations that mined the rich codfish population from two of the region's rocky outposts: Damariscove Island and Cape Newagen. Soon homesteaders followed with their families to pioneer and farm on the frontier. They chose sites strategically located on watery crossroads, as did their nearby neighbors on adjoining peninsulas. The known documented homestead sites were two in East Boothbay, one in West Harbor, and one on Fisherman's Island. They were driven out during King Philip's War in the 1670s and King William's War in 1689.

The permanent 1730 Scotch-Irish settlement of Boothbay finally tamed the peninsula, putting it back under the plow for good. Led by settler Samuel McCobb, the pioneers were apparently scattered along the shore near the sheltered main harbors. Initially, they built rude log houses; gradually, as time allowed or fire demanded, they replaced them with timber-framed houses. The settlers' struggles on the frontier were capped by more American Indian wars.

By the time of the Revolution, Boothbay men were accustomed to a seagoing life, and they manned privateers against the freely roving British. The enemy used Boothbay as a provision site (as it did during the War of 1812), liberating goods and livestock. The town was chronically low on ammunition to fend off raids.

The stability of the early and mid-1800s provided good years for Boothbay. Most families raised crops and had at least one cow and a pig; however, three-fifths of the men still were employed at sea. Many were gone for weeks or months at a time, fishing the banks or coasting to southern waters. After *c.* 1840, the timber framing of houses slowly evolved into modern stud-type construction. The Civil War broke into the peace and prosperity, disrupting daily life for hundreds of families. After the war, fishing and the other old-time rhythms were disrupted as well with the coming of the modern age and its features, which are depicted in the following pages.

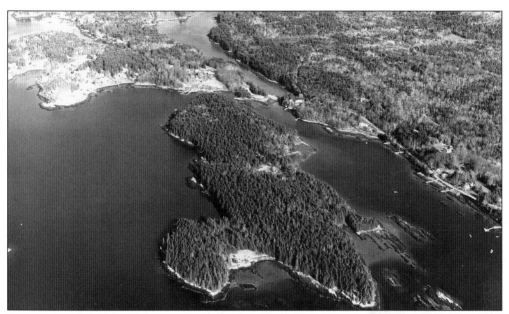

American Indians have been in Maine for about 11,000 years, and many sites date from 3,000 years ago to about 1600, when the people who lived between the Kennebec and the St. John Rivers were called the Etchemins. They left sites, including numerous shell heaps, in the Boothbay region, principally on Sheepscot River islands. Indiantown Island (above) is one of those islands, used for hundreds of years by the Etchemins. The Boothbay Region Land Trust, owner of part of Indiantown, sought to rediscover early living conditions on the island by underwriting two shell-heap digs in 1995 and 1996, supervised by archaeologist Deb Wilson. The team at the test pits is pictured below. In the group on the left are, from left to right, Pam Wilde, Marge Hanselmann, field crew chief Tim Dinsmore (wearing a hat), and Keith Hartford. In the group on the right are Stevie Hale (hidden), Barbara Rumsey (wearing a hat), and Barbie Eldred.

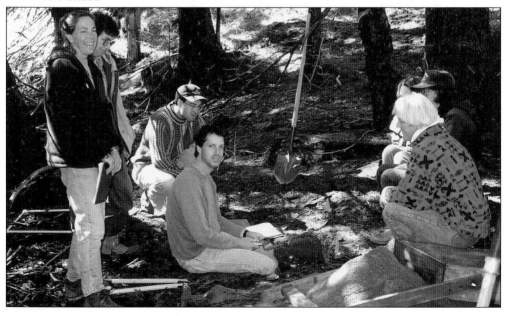

The first Euramericans who made extended stays in the Boothbay region came to fishing stations, locations where men processed codfish by salting them, drying them, or both. Once preserved, the cargo of fish was taken back to Britain and Europe for sale. Capt. John Smith charted Damariscove Island in 1614, when he was fishing nearby. A year-round fishing settlement existed on the island by 1622, when Plymouth colonists, short on food, sailed to Damariscove and were given provisions. This c. 1960 photograph shows that Damariscove has remained a destination for fishermen even to this day, nearly 400 years later.

The 1898 shoreline of Newagen Harbor at the tip of Southport, called Cape Newagen Island until 1842, is seen here. A 1600s fishing station occupied the spot. The station was well established by 1623, when English developer Christopher Levett visited and encountered two famous Maine American Indians, Menawarmet and Samoset, who befriended the white settlers. Samoset, from Pemaquid, greeted the Pilgrims in Plymouth soon after they arrived in 1620.

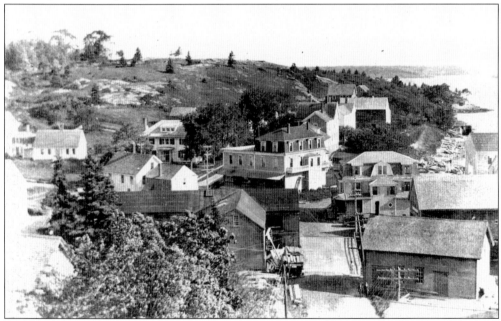

Henry Champnois was the first well-documented Boothbay settler. By 1665, he owned the east side of the peninsula, where he also lived. He first settled at Lobster Cove but moved his homestead to Barlows Hill in East Boothbay by 1670. Champnois had a gristmill on the village millpond. He was driven out by American Indians in 1689. The hill's tall trees mark the presumed general area of Champnois's house.

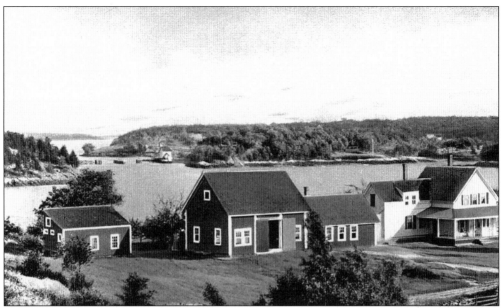

The American Indian Robin Hood deeded Henry Curtis much of Boothbay's west side in 1666. The Curtises lived on Boothbay Harbor's Oak Point, seen here in this southward view to the Southport Bridge c. 1940. Henry Champnois's son married Henry Curtis's daughter, tying the two early Boothbay families together. In 1690, Henry deeded his land to John Hathorne, who conducted some of the Salem witch trials.

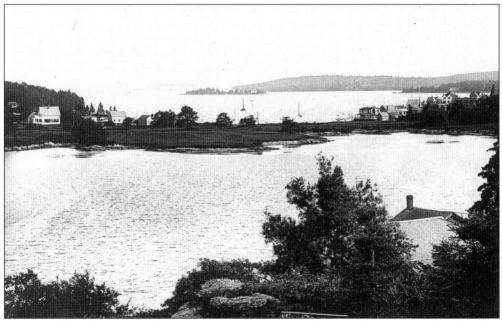

When mid-1600s midcoast Maine became a homestead destination, a few families lived in Boothbay. The East Boothbay "carrying place" is a known mid-1600s settlement site, where settler Walter Phillips may have lived before moving to Newcastle. The spot is a little neck connecting East Boothbay, Linekin, and Ocean Point to the rest of the town. The millpond appears in the foreground; Linekin Bay is beyond.

13

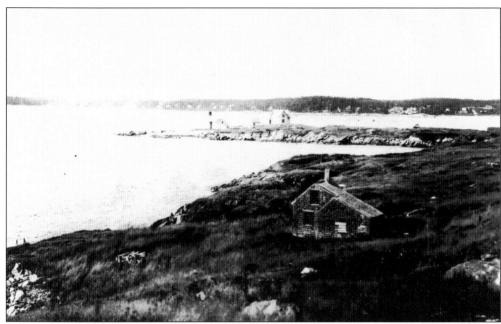

A Mrs. Phillips lived on Fisherman's Island, near Damariscove, in the 1670s, when she aided some Englishmen who had been shipwrecked while on a trading voyage. She lent them transportation, a shallop, so they could return to Boston. The old salt-box on Fisherman's, probably dating to the early 1800s, is in the foreground. Ram Island Lighthouse and the Boothbay shore are in the background of this 1900 photograph.

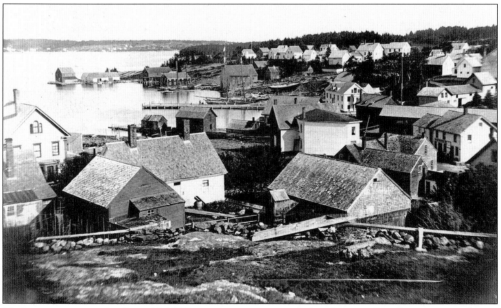

To become a town in the mid-1700s, a community needed to have a church or meetinghouse and a minister. The town was finally incorporated in 1764. In 1765, Boothbay built a meetinghouse at Boothbay Center, which was moved to East Boothbay in 1848. Torn down in 1944, it appears in the very center of this 1880s photograph: it is the two-story shipyard shop framed by two masts in the Adams shipyard.

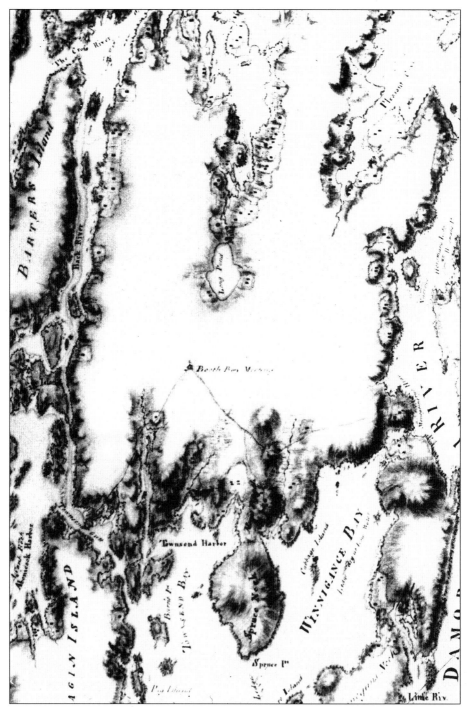

By 1772, when this map was drawn, nearly 100 houses stood in Boothbay, though two-thirds were still of primitive log construction. Log houses endured in Boothbay past 1800. The density of the map's black dots shows the most populous sections of town, up along the Sheepscot and Damariscotta Rivers, where the land, which was suitable for farming, was preferred over locations on the rocky peninsular points of land reaching into the ocean.

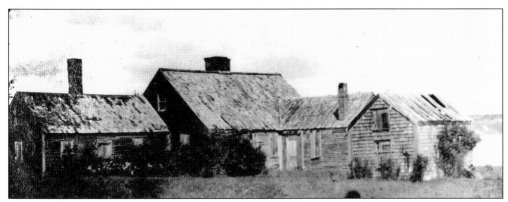

The majority of 1700s and early 1800s New England houses were Capes—low-posted, one-and-a-half-story houses with three or four rooms surrounding a center chimney. Such Capes were timber-framed, the skeleton consisting of large, hand-hewn beams. Seen here is a classic Cape hugging the ground. Its inclusion in local Welsh family albums suggests a riverfront location in Boothbay, but exactly where it was located is unknown.

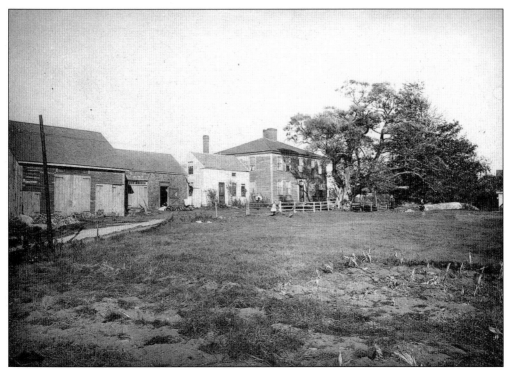

The main part of this old two-story East Boothbay house, still standing on Murray Hill, is an example of a common alternative for those who wanted something grander than a Cape. This house was built *c.* 1769 by Samuel Montgomery. Its chimney base alone, measuring 10 feet by 14 feet, is as large as some small houses. Long known as the Murray House, it served as an inn *c.* 1800.

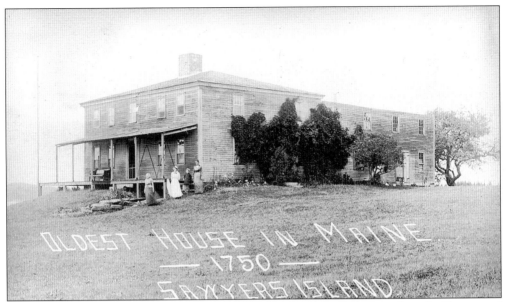

During the Revolution, the British harassed Boothbay region residents with raids. Houses and vessels were burned and livestock were forcibly taken, particularly in the outlying areas such as the islands of Fisherman's and Damariscove. In 1781, this Sawyers Island house was raided by the British and set afire. The owner, Benjamin Sawyer, was able to save it. The house, still standing, may date to the 1750s.

During the War of 1812, this gun house, intended as a storage building for weapons and powder, was built on a lot near Eastern Avenue in Boothbay Harbor, near a parade ground where local troops trained. The state of Maine sold the building in 1851 to the Holton family, and it was subsequently used as a carriage house. It is now located on Montgomery Road.

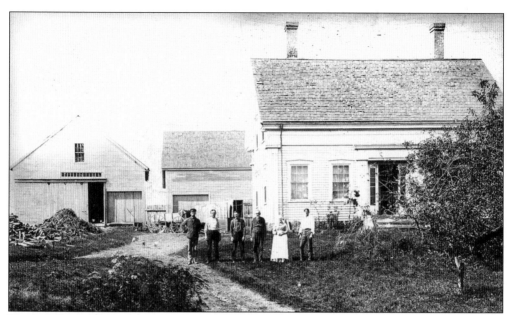

Toward the middle of the 1800s, Capes heightened, and builders abandoned timber framing for stick building, or stud construction. Center chimneys and cooking fireplaces became rarer with the introduction of stoves. The 1844 McDougall-Kelley house in North Boothbay, now the site of Boothbay Mechanics, burned in 1919. The John E. Kelley family poses in the yard in this 1910 view.

Boothbay sits on a rocky peninsula; the closer to the ocean, the rockier it is, as seen here on Damariscove Island c. 1910. The White Islands are seen to the northeast. Despite the inhospitable conditions, farming went on around the rocks that were too big to move, and the movable ones soon became walls and foundations. Cattle pasturing by the ocean had the luxury of fewer insect pests than those more inland.

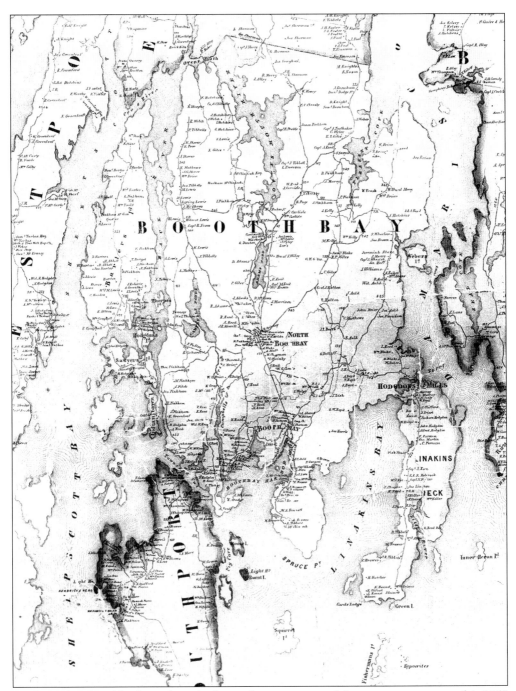

By the 1850s, Boothbay's residents had spread to every part of the region, as seen on this 1857 map. Defining the west side is the Sheepscot River with its Boothbay islands, while the east side ends at the Damariscotta River; Edgecomb is above and the ocean below. The population of Boothbay was about 2,800 in the 1850s, while Southport had only a few hundred people.

In 1864, at age 19, Frederick Giles enlisted in the 1st Maine Cavalry. Wounded at Appomatox, he was said to have held a whole battalion at bay for several hours with his single carbine and cartridges gathered from the belts of his dead comrades. He was one of the region's three premier heavy-construction workers of his time: a stoneworker; a road, wharf, and foundation builder; and a house mover.

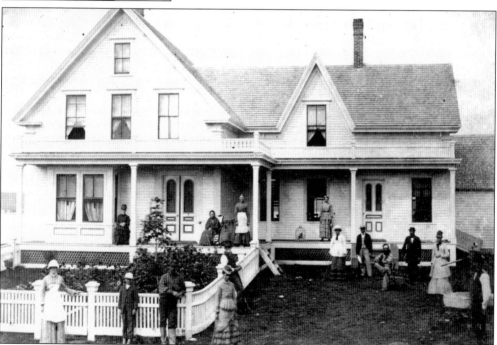

This Linekin house, seen c. 1900, was built by the Holbrook family and is an example of a New England farmhouse, a style dating to the 1860s and later. The main door has moved around to the gable end, and there is usually a kitchen ell with another door. An unknown East Boothbay builder at the time was very fond of sharp, tall gables, a prominent feature in the village and nearby locations.

# Two
# MARINE TRADES AT SEA

Given that the Boothbay area is surrounded by navigable water, its people have naturally gone down to the sea in ships and done business on the great waters. This business falls into three general categories: carrying people, carrying freight, and fishing. Ancillary to these are other important activities, such as the work of the Coast Guard, the U.S. Bureau of Fisheries, tugboats and pilots, and various scientific research entities.

The harvesting of fishery products has always been big business in the Boothbay region, and while some is done on the shore (such as clamming and worming), most is done at sea. Whether using passive gear, such as lobster traps or floating pound nets for mackerel, or the more aggressive techniques of trawling and purse seining, fishermen go to sea and take its hardships in boats ranging from the ubiquitous dories to the big schooners or diesel-powered draggers. The varieties of fish hooked by Boothbay boats include cod, hake, haddock, and halibut. Netted fish are sardines (small herring), mackerel, and pogies (menhaden). With the development of more powerful and dependable engines, beam trawling and otter trawling became preferred methods for catching various kinds of ground fish.

Freight was traditionally carried by sailing vessels—from sailing scows and small sloops and schooners to great schooners with three to six masts. Cargoes of lumber, ice, bricks, granite, lime, and fishery products left Maine waters for southern ports, the Caribbean, and South America; the vessels might return with coal, produce, molasses, or manufactured goods.

From the mid-1800s to c. 1930, a large part of the traveling public and a good part of the local freight went by steamboat. Between 1900 and the 1920s, more than two dozen steamers or steamboat lines plied the waters in and around Boothbay and traveled to Boston and down East. Boothbay was a center for steamboat traffic on the Kennebec, Sheepscot, and Damariscotta Rivers. Even in their glory days, however, steamboats were more than basic transportation. Most featured frequent recreational excursions and outings when scheduling permitted. That aspect survives today in the plethora of passenger boats busily plying the local waters during the tourist season.

Accessories to these seafaring industries have been the government fish hatchery and research laboratory on McKown Point, the Coast Guard lifesaving station on Damariscove Island, the buoyage and lighthouses, and waterborne businesses such as wharf builders and fuel suppliers.

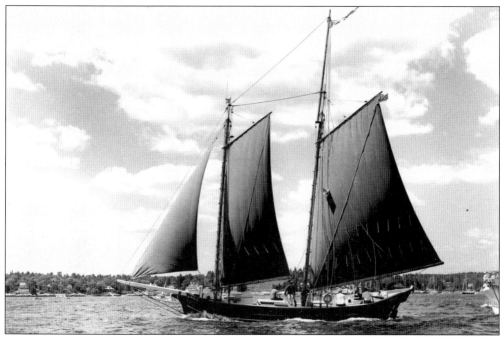

The pinky schooner *Maine*, a historically accurate replica of a typical 1800s local fishing vessel, sails near Boothbay Harbor. Pinkies featured tapered sterns surmounted with upswept, overhanging poops, somewhat resembling the sterns of fishermen's dories. She was built by the Maine Maritime Museum, and her lines were adapted from an 1830s builder's model at the Boothbay Region Historical Society.

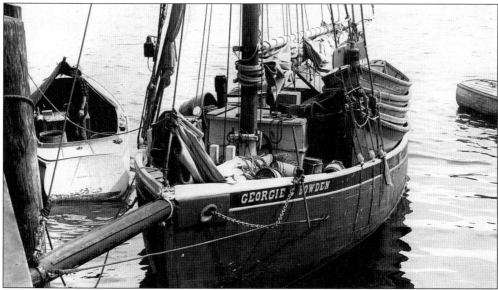

The nested dories on the fishing sloop *Georgie Bowden* indicate she was a line or tub trawler for cod or halibut. As such, the mother ship would go to sea with several dories. On the fishing grounds, the dories, with a crew of two men, would set out long lines to which were attached "gangeons" (lines with baited hooks). Later, the lines, or trawls, would be hauled in and the fish taken off.

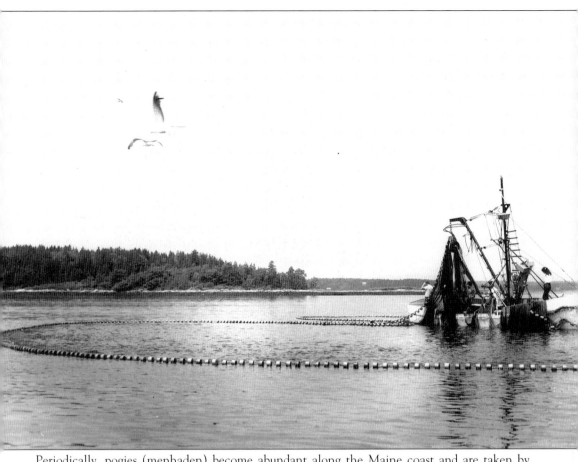

Periodically, pogies (menhaden) become abundant along the Maine coast and are taken by purse seining to be processed for oil, fertilizer, or fish meal. The purse seine, first used in Rhode Island, was introduced into the Maine fishery shortly after the Civil War by Luther Maddocks of Boothbay, among others. This photograph shows the use of a purse seine in more recent times near Boothbay. Although technology has improved the equipment, the technique has changed little. A school of fish is encircled with a long net. When the two ends are brought together, the bottom edge is gathered tightly with a purse line, essentially imprisoning the fish in a huge bag. Then, by hauling the line in from one side, its volume is continuously reduced until its contents can be bailed or dumped into the seining vessel.

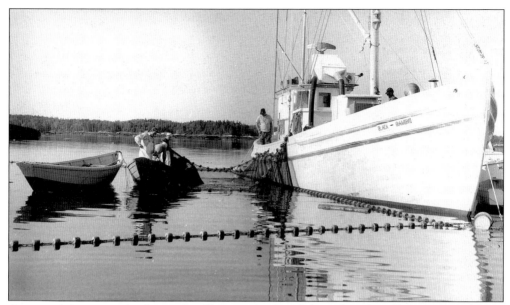

A crew prepares to unload a catch of herring (sardines) from the "shutoff" into the hold of a sardine carrier for transport to the cannery. Although this photograph was taken in the 1970s, during the sunset years of the fishery, the procedure had changed little from its earlier heyday.

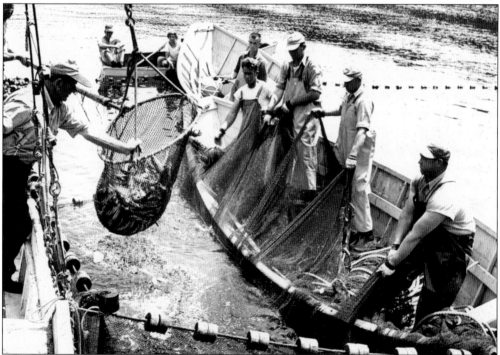

From left to right, fishermen Chester "Dick" Tibbetts, Leon Tibbetts, Max Tibbetts, David Reed, Earl Dodge, and Clinton "Tince" Tibbetts bail herring into the sardine carrier *Madeline* from a stop seine at Tibbetts Cove, Linekin Bay, in July 1949. Here, the fish are transferred the old-fashioned way with a bailing net, like a giant dip net; today, fish are moved with pumps. Ocean Pointers Mr. Bosworth and his daughter Natalie observe.

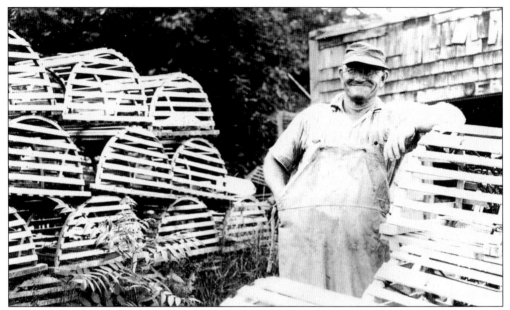

Fred Brewer, seen here in 1945, lobstered out of Little River on Linekin Neck in the early and mid-1900s. Born in 1897, he died in 1957. His trap storage site was on the west side of the inlet. Only a handful of men, mostly other Brewers and Poores, fished out of there then, and their catch was collected by a lobster smack that came on a regular schedule.

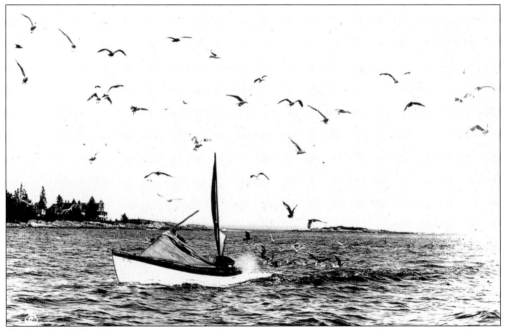

This early 1900s lobster boat is equipped with a canvas spray hood, which gave some shelter from the weather and the spray the boat kicked up. She has an inboard engine and a wooden tub to store the lobsters or the bait for the traps. Aft is a steadying sail, which would also keep the boat into the wind, bringing her home if the engine failed.

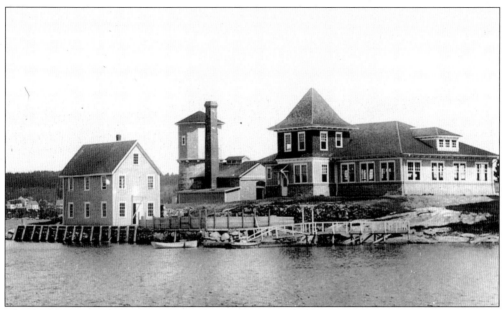

The hatchery on McKown Point is shown here shortly after completion. Built by the U.S. Bureau of Fisheries in 1905 and originally intended to rear young lobsters in hopes of bolstering the natural stocks, it eventually hatched cod and flounder eggs as well. The hatchery ultimately became a fishery research laboratory, first for the federal government in the early 1940s and then for the state of Maine in 1974.

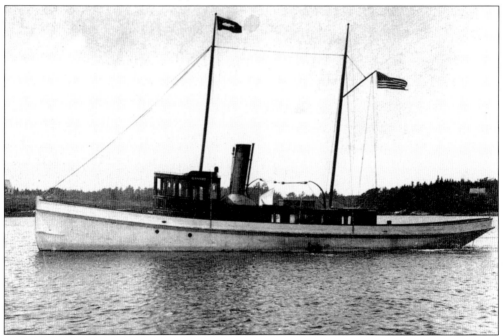

The U.S. Bureau of Fisheries steamer *Gannet*, a converted yacht once named *Carita*, served the needs of the hatchery on McKown Point from 1907 to 1927, collecting lobsters and ground fish for eggs and distributing the fry at sea. Capt. George Greenleaf and five men were regularly employed on her.

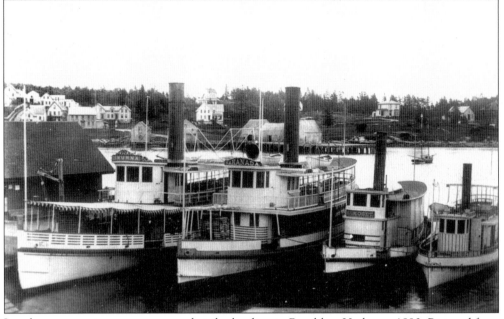

Local passenger steamers are moored at the landing in Boothbay Harbor c. 1890. Pictured from left to right are the Bath-Boothbay steamer *Wiwurna* (1884–1925); her partner on the same run, *Nahanada* (1888–1925); *Samoset*, built in 1873 and later renamed *Damarin*; and the little Boothbay-Wiscasset *Winter Harbor*, built in 1887.

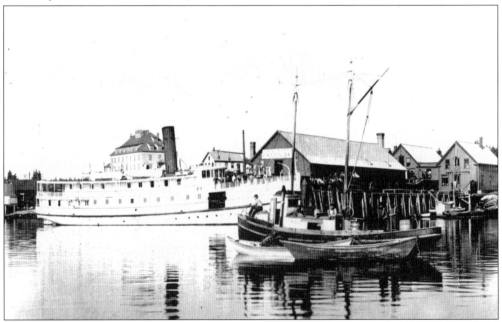

The steamer *Salacia* appears at a wharf on the east side of Boothbay Harbor, near the Menawarmet Hotel. The *Salacia* ran between Boothbay Harbor and Portland from 1895 to 1899. The steam herring seiner *Kearsarge*, with her dories, is in the foreground, near the F. C. Littlefield cannery, where townspeople and fishermen could obtain groceries and bait. It is now the site of Roeboat Enterprises.

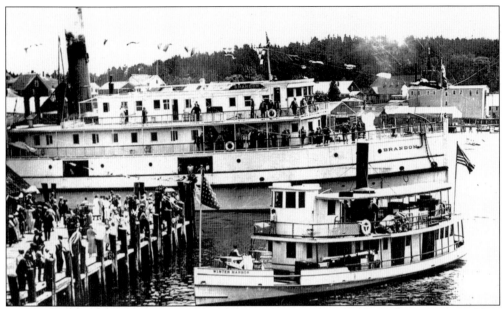

In the late 1920s, the Eastern Steamship Company ran steamers from Boston to Boothbay Harbor. This photograph shows one of them, the *Brandon*, at the Eastern Steamship wharf in the harbor. The smaller steamer is the *Winter Harbor*, which ran to Wiscasset until 1932. An oar held up in a nearby dory or skiff signaled to a small steamer that it should pick up a passenger or take the boat in tow.

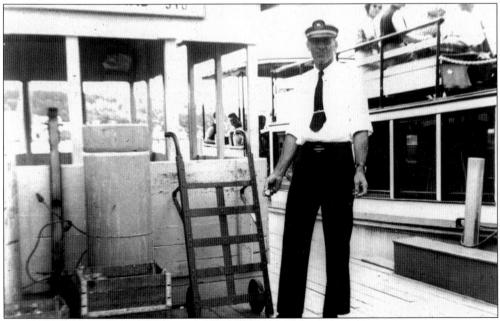

Capt. Ross Dickson began his steamboat career on the tug *Seguin* in 1907. He was captain of several local steamers, including the *Wiwurna*, *Nahanada*, and *Winter Harbor*, and was a ship's officer on many of the larger Eastern Steamship Company vessels, such as the *Calvin Austin* and *City of Bangor*. After retirement, he skippered the *Nellie G II* between Boothbay Harbor and Squirrel Island for many years.

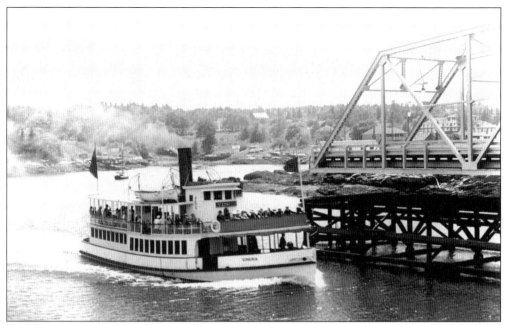

The steamer *Virginia* passes through the Southport Bridge *c.* 1940. The present bridge, shown in the photograph, was completed in 1939. The *Virginia* ceased operations in 1941. Built in Bath in 1909, she spent her early years in service on the Kennebec River, but, in 1922, she was transferred to the Bath-Boothbay Harbor run through the Sasanoa River and Townsend Gut.

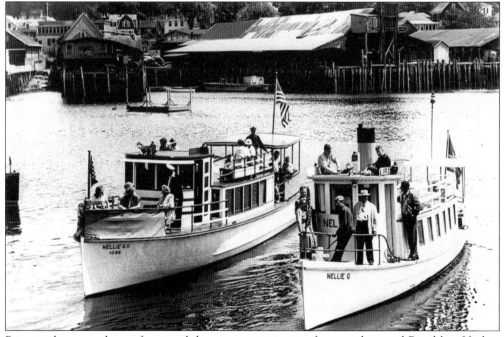

Prior to the general use of automobiles, transportation to, from, and around Boothbay Harbor was by water and often by steamer. Here, the Squirrel Island ferries *Nellie G II* (left) and *Nellie G* are shown in a rare appearance together in the early 1930s in Boothbay Harbor. Pierce & Hartung's coal and hardware business is in the background.

The *Governor Douglas*, the ferry and mail boat that ran from Boothbay Harbor to Monhegan Island from 1916 to 1935, leaves for the island *c*. 1930, after her conversion from steam to diesel power. Pierce & Hartung's coal facility and Reed's shipyard provide a backdrop along the shore.

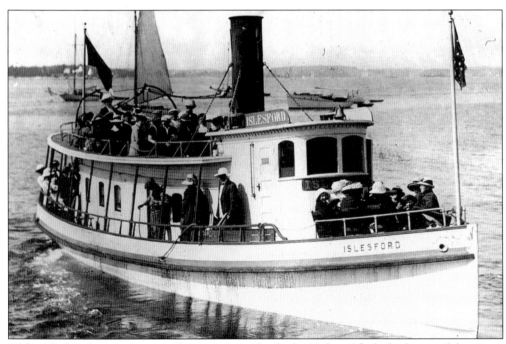

Although her home port was Damariscotta, the little 49-foot *Islesford*, skippered by Capt. Plummer Leeman, spent many years in the early 1900s as an excursion boat around Boothbay Harbor. Excursion boats are still a large part of local summer business.

# CHEAP! CHEAP! CHEAP!

# EXCURSION
## —FROM—
# BOOTHBAY TO BATH

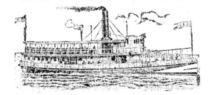

# SATURDAY, OCT. 3, '85

## BY EASTERN STEAMBOAT CO.'S STEAMER.

Leaving Boothbay at 8 A. M., landing at West Harbor, Southport, Sawyer's Island, Riggsville, Westport (Upper and Lower.)

Returning, leave Bath at 2.45 P. M.

**JUST THINK OF THE LOW FARES:**
**Children,** (Under 12 Years), **15 Cents**
**Adults, 35 Cents.**

H. W. Howard P't'g Co., Centre Street, Bath, Me.

It might seem that, before good roads and automobiles, steamboat lines should have enjoyed a virtual monopoly in local public transportation. Collectively, they may have, but business among individual lines could be highly competitive. Filling in slack periods with prominently advertised excursions and recreational travel was one means of boosting business.

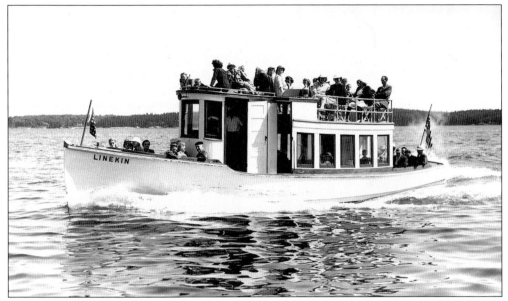

Steamers were eventually supplanted by gas-powered craft. The little gas-powered *Linekin*, in addition to making regular excursion trips, served as a water taxi. She picked up passengers at various landings, public or private, especially around Linekin Bay, and transported them to Boothbay Harbor for shopping and other errands in the days before residents had their own automobiles.

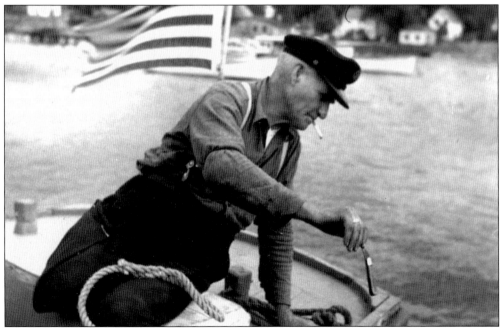

Capt. Will Barter (1877–1965) was a familiar waterfront figure. After going to sea for many years as a younger man, he worked as a local party-boat captain from 1933 to 1950 with his *Whitecap*. As he aged, his diabetes caught up with him; in this photograph, he has lost most of one leg, and he would also lose the other. Pictured in 1948, Barter has just finished splicing an eye into a rope on his boat.

With the rise of the gasoline engine, boats needed fuel. The first supplier in Boothbay Harbor was Lyman Orne of Lobster Cove, followed by Hite Thurston in 1904 and Peleg S. "Pal" Patten in the 1910s, whose barges are seen here. Pal's son Roy joined the business in 1923 and sold out in 1941. The barges' location in the harbor accommodated the boat owners and minimized the fire danger ashore.

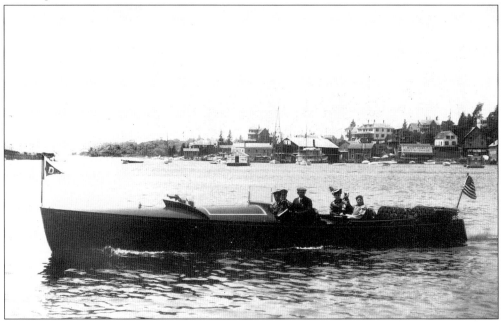

This 28-foot launch was built for Squirrel Island summer resident Alice Davenport by Hodgdon Brothers shipyard in 1913. It was just the sort of boat that needed a gas barge, seen in the background with the Commercial Street waterfront beyond. In the boat, from left to right, are Thel and Pearl McPhee, John Swett, Alice Davenport, her dog, and her adopted American Indian child.

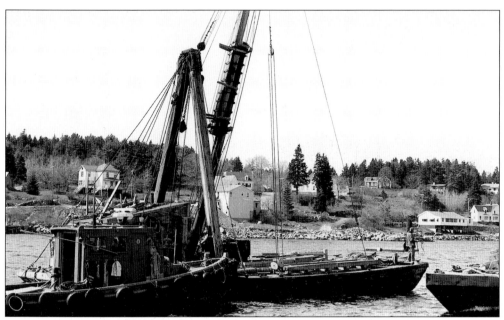

Marine contractor Mace Carter and his c. 1905 60-foot steel barge, the *Edwin Golding*, were a familiar sight in the region for decades. Mace's 42-foot towboat, *Hi M*, built by Cecil Pierce in 1955, nudged the barge into local bays and coves to do its work, as seen above in the 1970s in Mill Cove. Mace died in 1978 after 40 years of working along the shore: diving; building and repairing wharves, docks, and launching ways; and doing mooring jobs. In the 1970s, his crew of five, some of whom are seen below, included Carroll Perkins, Elwood Perkins, and Randall Bennett, all of whom spent decades of time with Mace. Rideout Marine bought Mace's gear after his death.

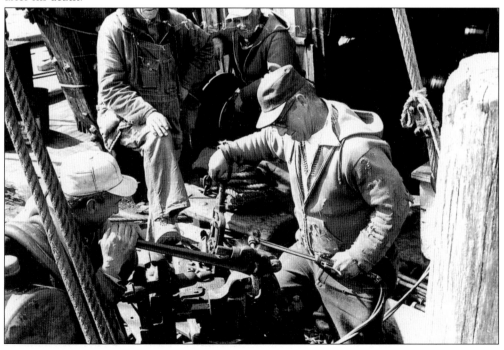

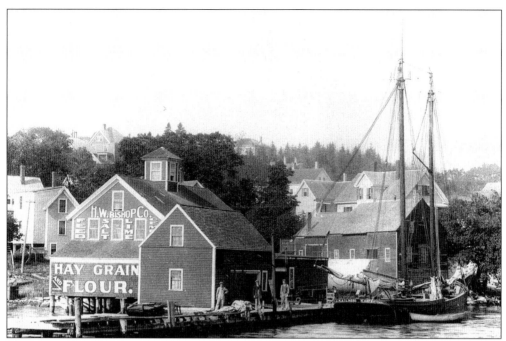

The coasting schooner C. M. *Gilmore*, owned by Harold W. Bishop, delivers supplies to Bishop's grain mill. The mill carried grain, flour, cement, lime, plaster, water pipe, seeds, fertilizers, farming implements, oil, gasoline, and poultry supplies, most of which came by coaster. Bishop started the business at that site and ran it between 1909 and 1915. He sold out to his employee Burt Hume.

Shallow-draft coasters were still used up to the 1930s for seaboard lumber and coal deliveries to coastal communities. Here, the Wasson's 122-foot *Henry H. Chamberlain* is tied to the Perkins & Stevens coal wharf in East Boothbay c. 1935. Built in 1891, she lost her main topmast in 1931; it was never replaced. She struck a ledge in Nova Scotia in 1937 and was a total loss.

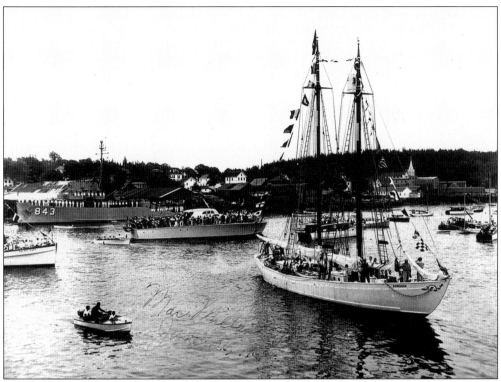

Above, the schooner *Bowdoin* leaves Boothbay Harbor for the Arctic on her 30th and last trip in June 1954. Commander Donald MacMillan and the *Bowdoin* made many such voyages from the harbor between 1921, when the schooner was built at Hodgdon Brothers in East Boothbay, and 1954. The geophysical research voyages were made under the auspices of several organizations, such as the Carnegie Institution, the National Geographic Society, and the U.S. Navy. Capt. MacMillan (left) appears aboard the *Bowdoin* in Boothbay Harbor at the time of one of his 1920s voyages. The son of a Grand Banks fishing captain, MacMillan was born in Provincetown, Massachusetts, in 1874. He attended Bowdoin College in Brunswick, became acquainted there with Robert Peary, and accompanied him on a 1908 expedition to the North Pole.

By 1930, the Great Depression and other economic and technological factors had virtually put sailing coasters out of business. Many of them remained idle in protected harbors, awaiting work. One such coaster was the *Sally Persis Noyes* (above), renamed *Constellation*, anchored in Little River while being refitted as a passenger-carrying school ship in 1933. Robert Royall of Little River hired local shipyard workers (below) to refit the schooner. Pictured, from left to right, are caulker Gus Tibbetts, Mel Alley, R. R. Shackleton, painter Freeman Tibbetts, joiner P. W. Shackleton, Dan Alley, Rich Brewer, and caulker Wilbur Pinkham. The work included the addition of staterooms, a dining area, a library, an up-to-date galley, and modern sanitary facilities. In the mid-1930s, the vessel became a restaurant and club ship.

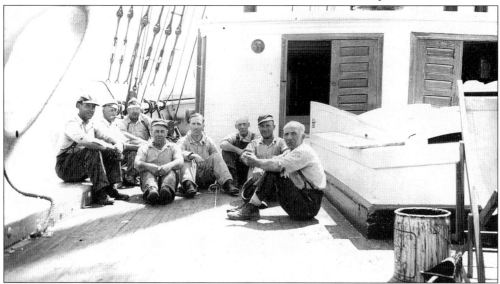

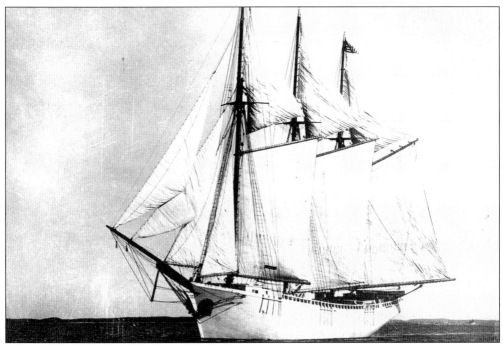

Much of the maritime commerce in and out of Boothbay was coastal, handled both by steamers and by sailing vessels. The latter ranged from small sloops to large schooners with two, three, and four or more masts. Shown here under sail is a typical coasting schooner, the three-masted *Ada Cliff*. She was built in 1916 by the East Coast Ship Company of Boothbay Harbor.

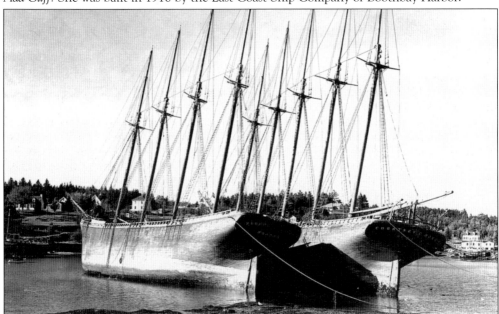

Two abandoned coasting schooners await the scrap heap in the mud flats of Mill Cove c. 1940. The remains of the *Courtney C. Houck* (right) are still there. The bones of the other, the *Zebedee E. Cliff*, now serve as a breakwater in Casco Bay near Portland. The *Zebedee E. Cliff* was built in 1920 at the same Boothbay Harbor shipyard as the *Ada Cliff*, seen above.

# Three
# MARINE TRADES ASHORE

Because many Boothbay residents sought their fortunes at sea, it was not unexpected that they and other entrepreneurs would find corollary enterprises ashore. For the fishermen, facilities for landing, processing, storing, and marketing their catches were obviously necessary. Age-old methods of fish and shellfish preservation were drying and salting. Toward the end of the 1800s, preserving by means of canning and freezing became prevalent, and several canneries and cold-storage plants were established. The use of fishery products as raw material for oil and fertilizer led to the establishment of additional processing facilities, such as pogie factories, in the same era.

One shoreside adjunct to the fishing industry was the bait business. Before the era of tourists, restaurants, and fried clams, the soft-shell clam was one of the standard items for baiting the hooks of the hand-liners and line-trawlers, and there were plenty of them in the local mud flats. The "racks," or backbones, of filleted fish were a by-product used for lobster bait, as were alewives caught in local streams. The lobsters themselves, if not shipped, canned, or eaten right away, were held in pounds, which could be anything from saltwater ponds with grids across their entrances to floating wooden boxes called "live cars."

Products from the sea are not the only seaside industries, however. Seagoing vessels need to be built, equipped, maintained, provisioned, provided with lighthouses, and, someday, scrapped. Boothbay has accommodated all of these needs. Marine railways provided places where vessels could be hauled out temporarily for repairs or bottom painting. Sail lofts were available to make or repair sails, and chandleries supplied paint, hardware, or navigation instruments.

As the voyage of its life came to a close and a ship was deemed no longer seaworthy, something had to be done with its remains. Much of its hardware was still of value, and it was worth somebody's time and effort to salvage it. This created a profitable business; in earlier days, whatever was left was often abandoned on the mud flats.

The use of small- and medium-sized pleasure craft has grown exponentially in later years. As living on or owning land next to the water is no longer the norm for boat owners, boatyards, often well inland, turn more to storage of such craft. Marinas with rental slips have grown just as quickly.

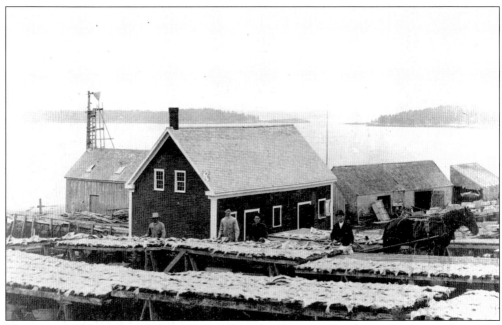

This typical 19th-century flakeyard, owned by the Cameron family on Southport, shows the age-old preservation process. Codfish, gutted and salted at sea, were landed in barrels from the fishing schooners, then washed and spread out to dry in the sun on racks called flakes. The dried fish, turned and protected from bad weather for about a week, would keep indefinitely.

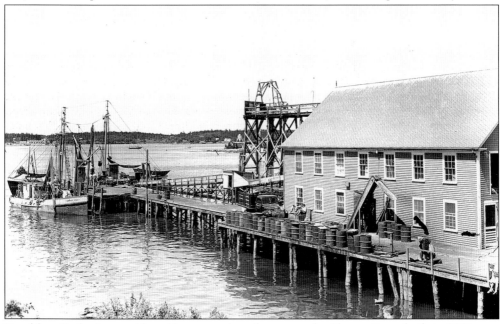

Boothbay Harbor's east-side cold storage plant, known as the "freezer," was built in 1919 on a sardine cannery site. By 1925, it had come into full operation for the cold storage and freezing of fish and the artificial manufacture of ice. This photograph shows the building and wharf as it appeared in the late 1940s or early 1950s. A wooden-hulled, New England–style side trawler appears at the wharf.

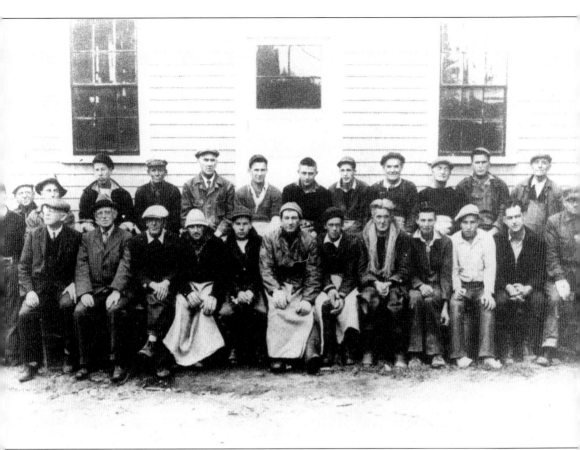

The freezer was a five-story building measuring 100 feet by 65 feet. It specialized in herring bait and mackerel in the early 1900s, then on redfish and whiting after mid-century. At times, 50 or more people worked in the building processing fish. It was damaged by fire in 1943, rebuilt, and destroyed completely by fire in 1978. Employees posing for an October 1937 photograph are, from left to right, as follows: (first row) John P. Kelley, Cecil Low, Luther Pinkham, Clayton Parmenter, Parker Leeman, Frank Sargent, Kenneth Pinkham, Fred Warren, Richard Dighton, Myron Robinson, John S. Kelley, and Richard Barlow; (second row) Gordon Yates, Lester Bennett, Lou Yates, Tom Pinkham, Manley Poore, Walter Symonds Sr., Lowell Sproul, Walter Symonds Jr., Bradford Pinkham, Lou Barter, William Pinkham, Elmer Pinkham, and Sam Morton.

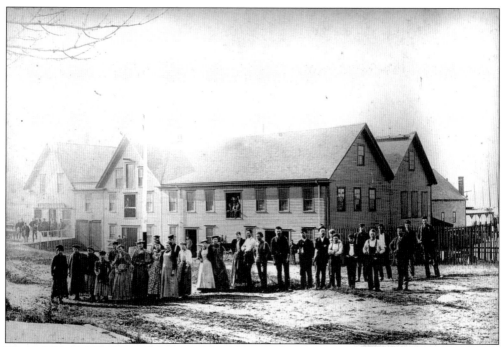

The Maddocks Packing Company (above) was a huge sardine cannery built by Luther Maddocks in 1878 on Boothbay Harbor's east side. In 1901, it was the biggest of its kind in Maine and perhaps in the nation, with three joined two-story buildings averaging 50 feet by 150 feet each. Adjuncts were a marine railway and smaller buildings, including a box-manufacturing shop, a carpenter shop, two buildings for storage, and one for feeding the army of employees. In the c. 1905 interior shot below, men in the sealing room solder the filled cans by hand. Each solderer had a little fireplace on his bench to heat the iron.

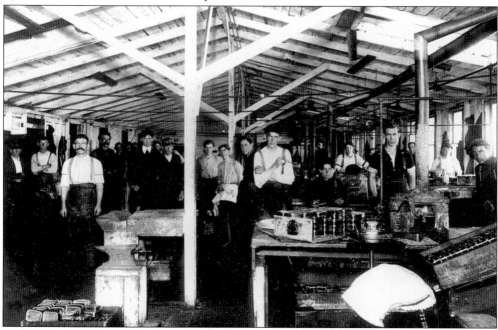

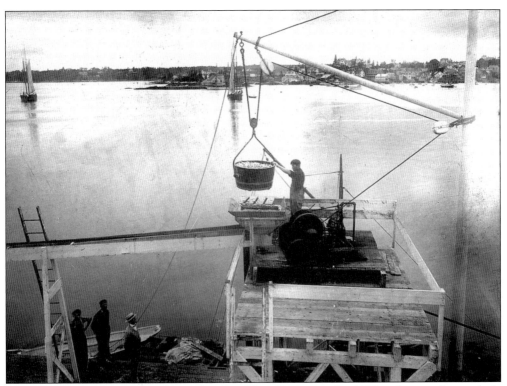

Seven sardine canneries were located in Boothbay Harbor in the 1890s—five on the east side and two in the West Harbor area. The factories had achieved a little mechanization by the time of this photograph: a gas-powered winch. At this east-side cannery, a tub of herring is swung in from a boat out of sight on the right.

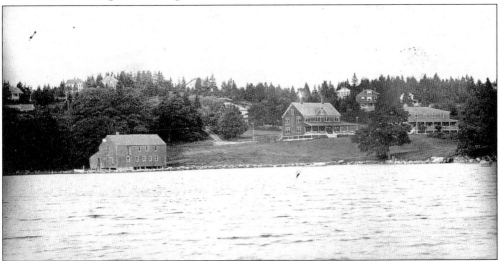

From the mid-1870s to the 1890s, a lobster cannery inhabited the barn at the water's edge on Lobster Cove. Besides lobsters, herring, mackerel, clams, and corn were also canned, as well as anything that could fit in a can. In 1896, the Barrett family built the summer place seen to the right. The site is now Barrett Park, a picnic area in the summer and a lobster trap storage site in the winter.

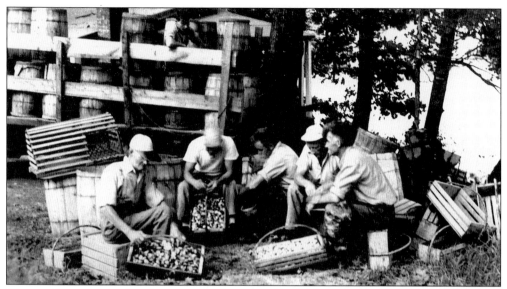

Chester Farmer opened a clam-canning factory at Back Narrows in 1914, moving a building across the Damariscotta River from Bristol to house it. Farmer's factory was located at the bottom of Camps Hill across from Fort Island. It operated until 1942, with as many as 50 men digging and processing clams. Chester's clammers (above), all Back Narrows men, check over their hods in the 1930s. The crew included, from left to right, Will Hutchins, Carl Doughty, Darrell Bryer, Gordon Bryer, and Harold Bryer. The man among the barrels in the stake truck is Shirley Cunningham. The canning label (below) for Farmer's factory covered each can.

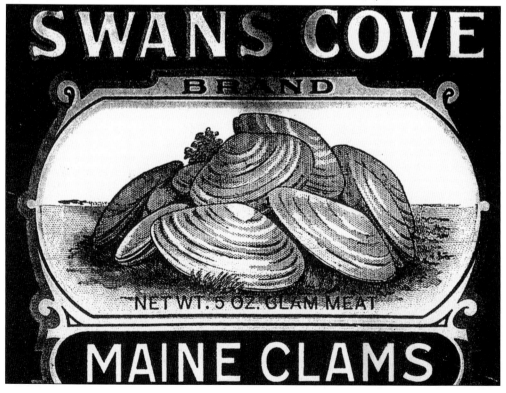

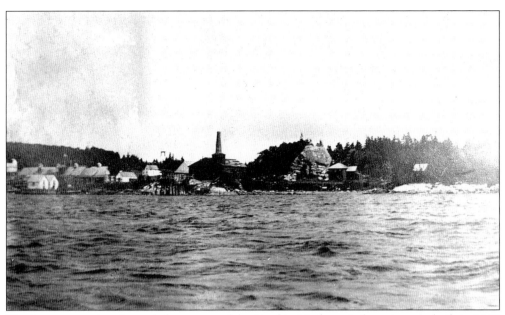

The huge enterprise pictured above, one of the Linekin Neck pogie factories, was built in 1866 by Gallup & Holmes of Connecticut. Pogies, or menhaden, were fish harvested for oil and fertilizer, and they were fickle about arriving. Lack of fish closed many factories in the 1870s. This one, now the site of Luke's shipyard, limped along, processing other fish and whales, and was torn down c. 1915. Barrels of oil (below), extracted under high pressure from pogies, lay in wait while being counted, soon to be loaded into the three-masted schooner alongside the stone wharf. The counting, done in the last quarter of the 19th century at Gallup & Holmes, is being done by Jainus Jones, at times a teacher on Linekin Neck.

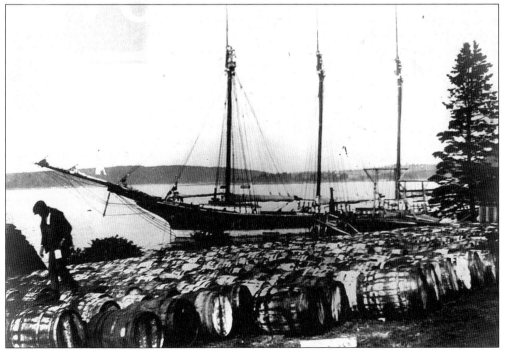

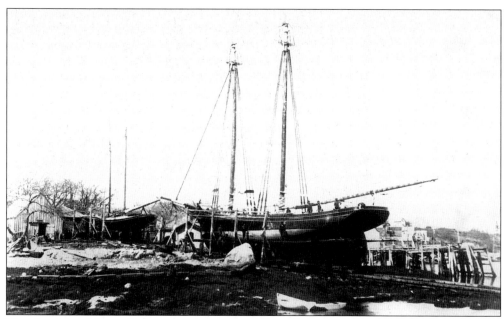

The Boothbay Marine Railway was created at West Harbor in 1867 at the urging of Joseph Nickerson. Almost all of the owners were local men with seafaring interests. The railway hauled as many as 100 vessels a year with a capstan driven by two horses. Despite remaining busy, it was not very profitable. The West Harbor railway survived until 1906 and is now the site of Oak Grove Condominiums.

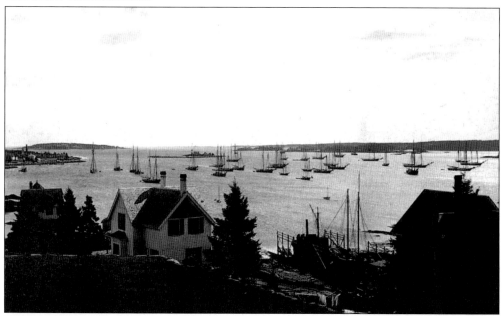

The 1869 Townsend Marine Railway, on McFarland's Point, was originally steam powered, rated at 12 horsepower. The railway continued in that location through the 20th century, becoming the Atlantic Coast yard and, eventually, Sample's shipyard. This c. 1900 view of the railway from McKown Hill shows a steamer and schooner on the ways and the mackerel fleet sheltering in the harbor.

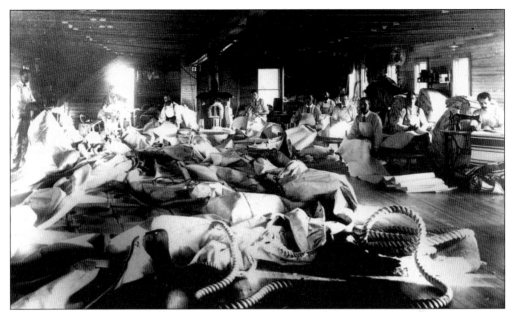

As long as boats have been built and repaired, sailmakers have been in Boothbay, usually working in the second story of commercial buildings. Shown here is the c. 1915 loft of Lewis A. Dunton in Boothbay Harbor's west-side cold storage, where he and his crew worked from the early 1900s to 1926. The World War I era was the last big crush of business for commercial sailing vessels.

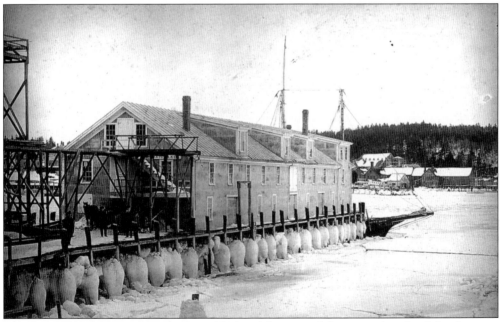

The west-side cold storage was built in 1916 and functioned for many decades. Like the east-side freezer, it specialized in herring and mackerel. No doubt this photograph dates to 1918, a year legendary for the hardship caused by the cold, preventing essential supplies such as coal from arriving. The building and wharf collapsed in 1932, including the sail loft occupied by John Howell.

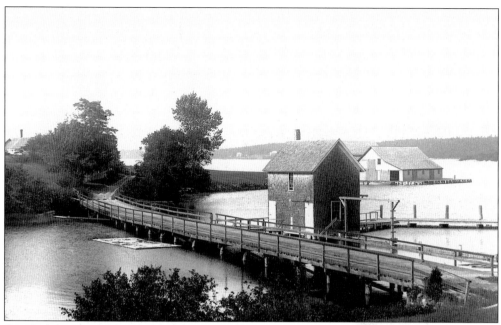

Caught lobsters are often held alive, sometimes in submerged slatted lobster cars or crates or in small "fenced" saltwater coves. They are then sold as the market demands. Historically, lobster pounds have been located all over the region. Originally a tidal millpond dating to the late 1700s, this Ebenecook Harbor site on Southport was transformed into a pound in the 1890s.

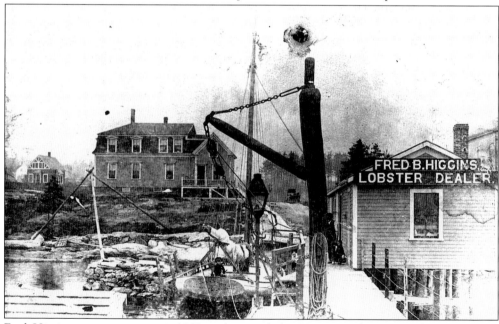

Fred Higgins came to town in 1899 and created the Higgins Lobster Pound on Boothbay Harbor's east side, toward the end of Road's End. He fenced a little cove in such a way that the saltwater could freely run in and out but the lobsters could not. By c. 1900, he was shipping thousands of lobsters a month. Higgins died in 1940, but his business continued until 1960; it is still a pound but is under different ownership.

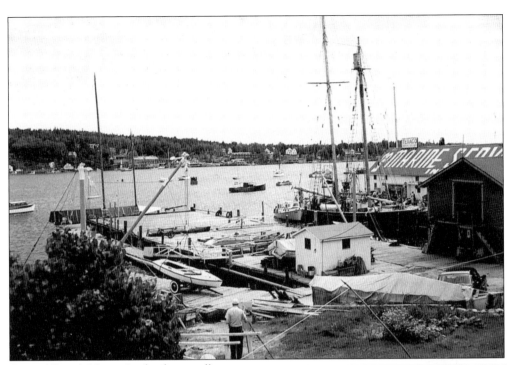

Capt. Albert McIntyre's wharf was well remembered on the Boothbay Harbor waterfront after he retired from captaining seagoing vessels in 1921. Most of his career at sea was spent on the Atlantic seaboard carrying cargoes from Maine in vessels he owned. But, like the local boys who went to sea at age 9 or 10, he had started on local mackerel schooners. After retirement, "Cap'n Al" ran the wharf, seen above in the 1940s with the *Bowdoin* tied nearby, on lower Commercial Street. He stored and repaired boats, and accommodated people with all things maritime. Equally familiar to townspeople was his pet cat (right), who greeted customers.

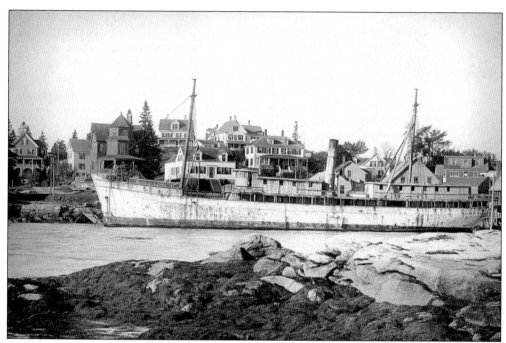

Wrecking commissioner Billy Sawyer's latest job is seen above on lower Commercial Street in the harbor. He stripped worn-out or wrecked vessels of all saleable parts. In process c. 1930 is the *Merida*, a steam passenger vessel built in Bath in 1911. Behind her bow and forward deck are the 1885 Blair house (with the tower) and the Bradley Inn (with the dormers), which was moved from Arrowsic in 1875. Below, the *Merida* has been stripped, towed around McFarland's Point to Mill Cove, doused with kerosene, and burned to extract all the metal fastenings for scrap. In the background is another stripped vessel, the *Fred C. Holden*. Along the shore, from left to right, are St. Andrews Hospital (obscured by smoke) and Keene Barter's sardine factory.

The burning of the *Merida* in Boothbay Harbor has left nothing but the passenger cabins, which had been located on deck. They were detached and sold by Billy Sawyer, floated around Spruce Point on scows, and hauled by horsepower up Mount Pisgah. They were then placed on land near the beginning of Weeks Road, becoming summer cottages.

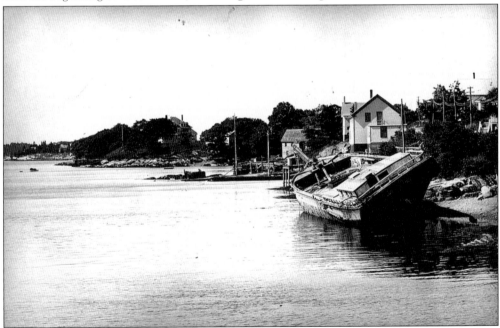

Boothbay Harbor's Mill Cove was a longtime vessel graveyard or junkyard. In the early 1900s, wrecking commissioner Billy Sawyer stripped and left the *Mary Weaver*, seen in the foreground. She was a well-loved wreck that had decorated the west side of Mill Cove for many years. Local people were sorry to see her go when she was demolished as a Works Progress Administration project in the 1930s.

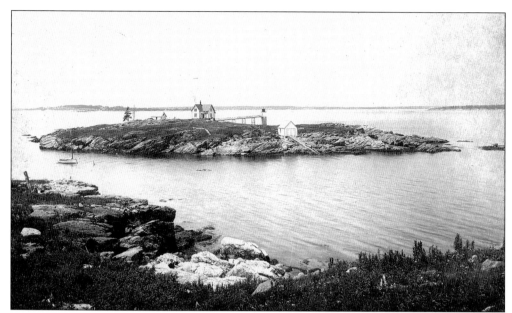

The federal government acquired Ram Island in 1837, but no lighthouse was installed until 1883. Local men are said to have maintained lanterns on or near the island in the 1800s before 1883. In first keeper Samuel Cavanor's 30 years there, wrecks on nearby ledges still averaged one every couple of years. Today, Ram Island Light is maintained by the Ram Island Preservation Committee.

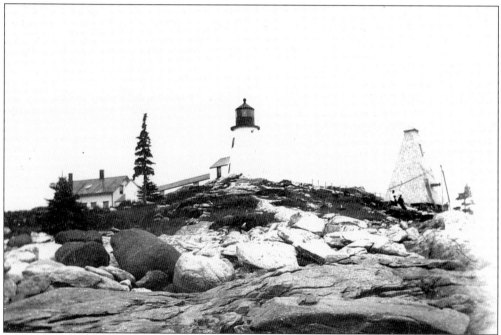

Burnt Island Lighthouse, established in 1821, was the first in the region. In this 1896 photograph, the building on the right houses the bell tower, while the light is behind it and the keeper's house is to the left. Today, it is owned by the Maine Department of Marine Resources, with Elaine Jones operating it as a living history museum, the Burnt Island Living Lighthouse.

# Four
# SHIPBUILDING

Wherever people settle by the sea, shipyards thrive, and that is true of the Boothbay region. Only sketchy references to 1700s shipyards survive. In the 1800s, most of the vessels launched were work boats, either fishing schooners or coasting vessels, including brigs, barks, and some ships, but few photographs document them prior to the 1890s.

During the early 1800s, many yards were located in the region. D. & J. Adams and Washington Reed were at North Boothbay, while Caleb Hodgdon, A. & W. Adams, Levi Reed, Benjamin Reed, Samuel Murray, and Jacob Fuller were in East Boothbay. Toward 1850, other builders joined the East Boothbay men, including Charles Murray, John McDougall, and W. & J. Seavey. Adams, Hodgdon, and Fuller's sons carried on into the late 1800s and early 1900s. By 1900, in East Boothbay, the Rices were well established, and by the mid-1920s, Goudy & Stevens had taken over the yard previously owned by Adams. Over the course of the 1900s, Rice's, Reed's, and Goudy's were supplanted or joined by other yards; some were one-man operations. Of the early yards, only the Hodgdon yard still operates. The first pages of this chapter cover East Boothbay yards, while Boothbay Harbor yards follow.

The sole known early Boothbay Harbor builder was E. B. Sargent, but by the mid-1800s, Stephen Sargent, Cyrus McKown, and John Weymouth had joined the ranks. In the early 1900s, Irving Reed started building on the harbor's east side, and his yard briefly became the East Coast yard during World War I, with its associated yard, Atlantic Coast, across the harbor on the west side. Just before World War II, Sample's shipyard took over the Atlantic Coast site.

Shipyards and boatbuilders have been subject to more boom-and-bust cycles than most industries. The peak 1900s periods of local shipbuilding resulted from wartime demands for commercial and naval vessels. Big schooners, subchasers, minesweepers, ocean rescue tugs, and coastal transports were built, along with small boats for the military.

In between peaks, the yards kept busy building yachts, trawlers, draggers, lobster boats, lightships, tugs, motor boats, and even toy boats. Today, much of the business is involved with boat storage and maintenance. However, Sample's specializes in rebuilding large wooden vessels of historic significance; Washburn & Doughty builds modern, high-powered steel tugboats; and Hodgdon Yachts, run by a fifth-generation shipbuilder, creates some of the largest and most sophisticated yachts in the world. And so, the tradition continues.

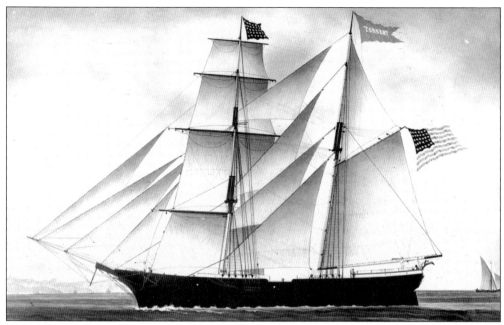

This painting shows the *Torrent*, a 107-foot hermaphrodite brig launched in East Boothbay in 1854, entering the port of Genoa in 1856 under Capt. Robert Montgomery of East Boothbay. On another *Torrent* voyage to the Mediterranean, Montgomery brought donkeys home, which delighted local children. The *Torrent* was abandoned at sea in 1877 and eventually landed at Havana; the crew was saved. (Courtesy of Bob Blake.)

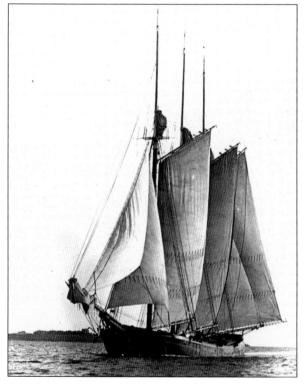

Jacob Fuller built the 116-foot coasting schooner *Abel W. Parker* in 1873 in his yard off Murray Hill Road in East Boothbay. The shipbuilding careers of Fuller and his son Jacob G. Fuller stretched from the 1830s to the 1890s. They built mostly fishing and coasting schooners of 60 feet to 100 feet; the largest was the 150-foot *Phoebe J. Woodruff*, built in 1882.

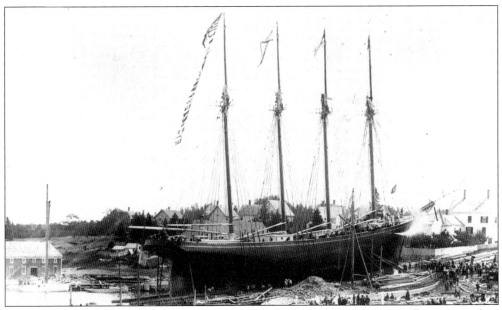

The Adams shipyard, now Hodgdon Yachts in East Boothbay, launched the *Elvira J. French* in August 1890. The first four-master built on the river, she was a 176-foot schooner with 154-foot masts. The *French* is blowing off steam at her bow, perhaps checking out her donkey engine. Nearly 3,000 people attended the launching. A celebratory ball took place that night at the new Citizens Union Hall.

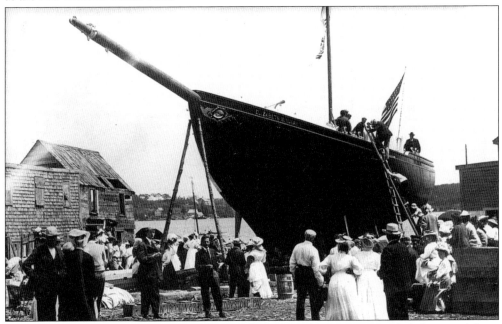

The output of East Boothbay's Hodgdon yard over nearly 200 years included many fishing vessels. The 96-foot auxiliary fishing schooner *Elizabeth W. Nunan* was launched in 1908, the last of six vessels Hodgdon's built for the Cape Porpoise Nunans. In an age before safety rules, 100 people were aboard for her trial run to Squirrel Island under engine power. She was still fishing in 1938 and perhaps beyond.

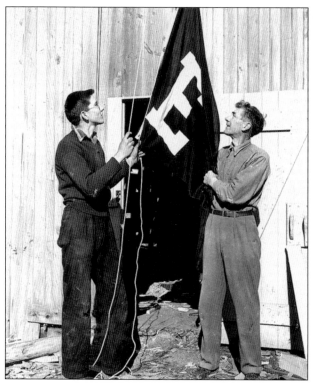

George I. "Sonny" Hodgdon Jr. and George I. Hodgdon Sr. raise the U.S. Navy "E" flag in April 1942 on one of the yard buildings. It was awarded to the team of Hodgdon Brothers and Goudy & Stevens for excellence in wartime shipbuilding; their work totaled two 97-foot minesweepers and 10 troop transports. More than 150 men worked at the yards during World War II.

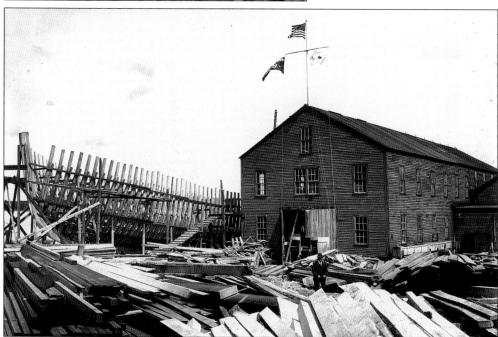

Hodgdon Brothers and Goudy & Stevens were building troop transport APc68 (also known as FT25) in November 1942 when the two shipyards were given another award for excellence, the Army-Navy E. The 103-foot transport is framed up next to the Hodgdon building, over which the Army-Navy E flag flies.

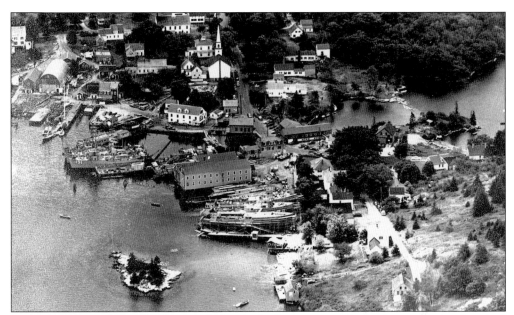

In the 1950s, Hodgdon Brothers and Goudy & Stevens joined together again, as they had during World War II, to build twelve 144-foot minesweepers for the U.S. Navy. This 1953 photograph shows a number of them under construction. All of these were transferred to other navies as part of the Mutual Defense Assistance Program. Despite the navy work, yachts were still turned out by the work force of 450.

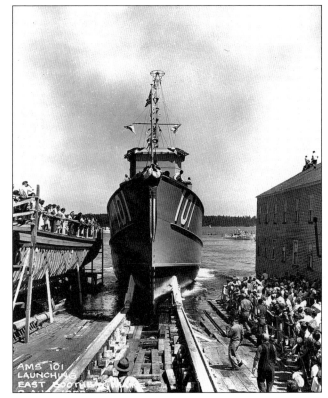

Minesweeper launchings in the 1950s were popular affairs. One of the 144-foot minesweepers glides down the Hodgdon Brothers ways to the river in August 1952, while spectators watch from a companion vessel alongside, framed up and ready for planking. As launchings become more mechanized, the old sight and smell of launching grease become rarer.

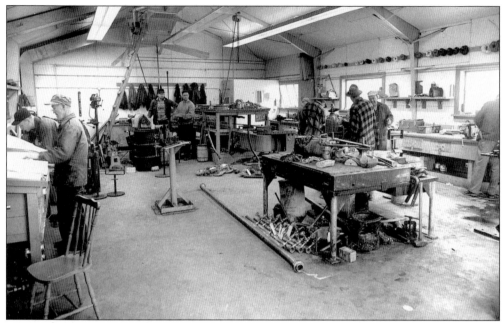

All the shops within the shipyards had jobs to do. In addition to doing outdoor work on the big wooden minesweepers, the workers in the joiner shops, pipe shops, paint shops, and machine shops prepared parts for the ships. This 1950s interior shot of the Hodgdon Brothers pipe and welding shop shows men turning out fittings for the minesweepers.

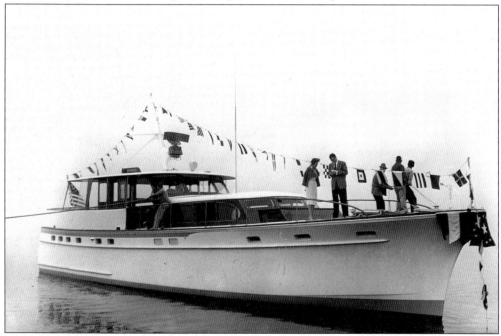

After the Korean War, shipyard work for the navy wound down, and the yards returned to the main focus on yacht work. Here, the *Maimelee*, a 67-foot luxury motor yacht designed by John Alden, has just been launched from the Hodgdon Brothers yard in East Boothbay in 1961. She was the largest fiberglass hull in the world when created.

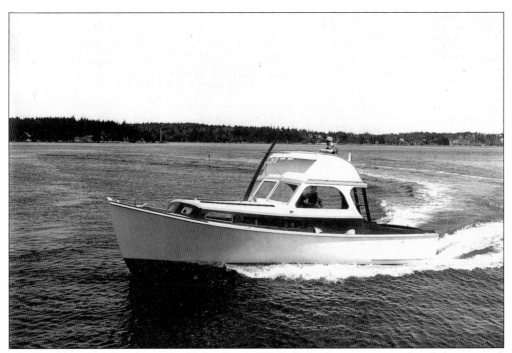

The Boothbay 33 (above) and the 65-foot *Lion's Whelp* (below) are two examples of pleasure craft built by the same crew at the Goudy & Stevens yard who, just a few years before, were building 136-foot minesweepers for the navy. Forty-two of the Boothbay 33s were built as stock boats between 1959 and 1961. The *Lion's Whelp* was a custom yacht built by Goudy & Stevens in 1966.

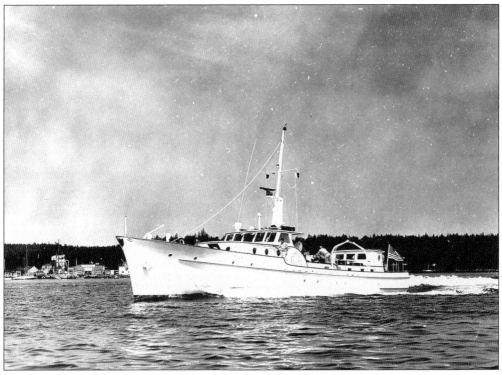

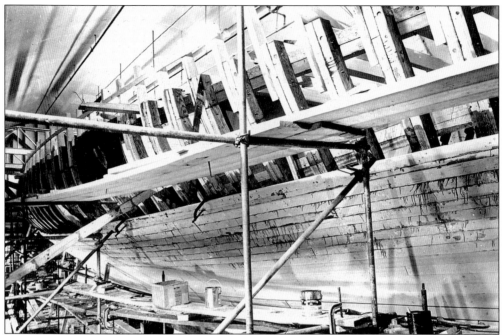

In 1967, Goudy & Stevens built a full-size replica of the famous 1851 sailing yacht *America*, for which the America's Cup race was named. The Schaefer Brewing Company commissioned the 106-foot replica, built from up-to-date plans provided by naval architects Sparkman & Stephens. Above, the *America* is planked. Her launching, below, attracted national attention and was attended by thousands, despite the raw May day.

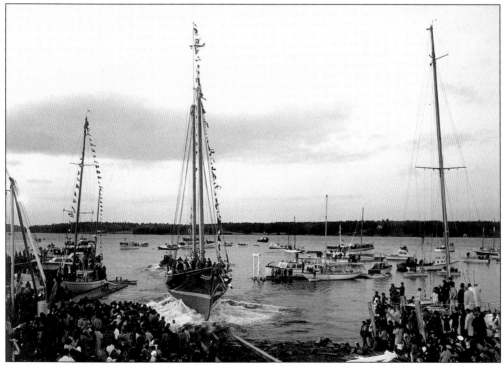

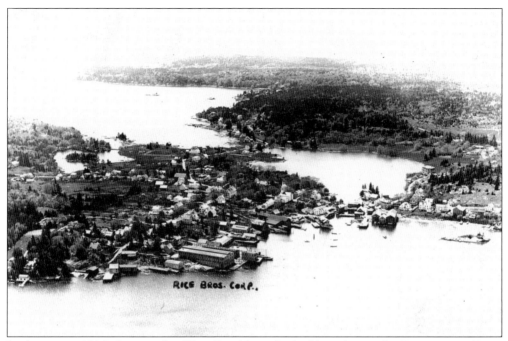

In this spring 1936 photograph of East Boothbay, the buildings lining the Damariscotta River in the foreground are, from left to right, those of the Rice Brothers Corporation (now Washburn & Doughty), the Frank Rice shipyard (now Shipbuilders Park), the Goudy & Stevens shipyard (now Hodgdon Yachts), and the Hodgdon Brothers shipyard (now Ocean Point Marina). The millpond is at the upper right; Linekin Bay is at the upper left.

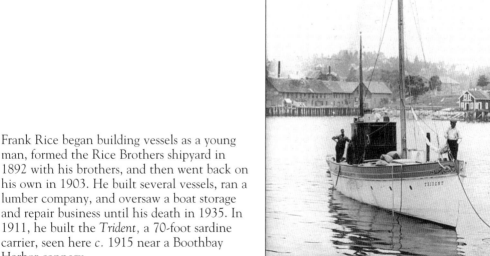

Frank Rice began building vessels as a young man, formed the Rice Brothers shipyard in 1892 with his brothers, and then went back on his own in 1903. He built several vessels, ran a lumber company, and oversaw a boat storage and repair business until his death in 1935. In 1911, he built the Trident, a 70-foot sardine carrier, seen here c. 1915 near a Boothbay Harbor cannery.

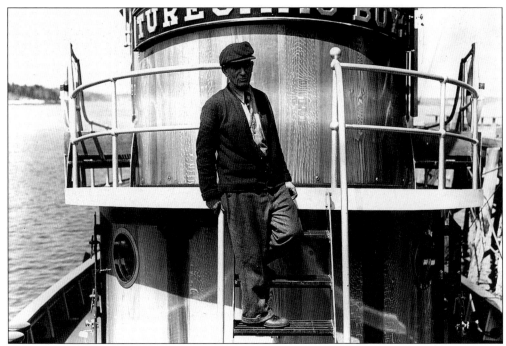

Henry W. Rice, a Rice Brothers shipyard founder, is shown here after launching aboard the steel tug *Turecamo Boys* in April 1936. The 100-foot oceangoing tug was lost with all hands in November 1941 off Greenland, with a fuel barge in tow. After his brother Frank left the yard in 1903 and his brother William left in 1945, Henry carried on shipbuilding until 1956. He died in 1959 at age 87.

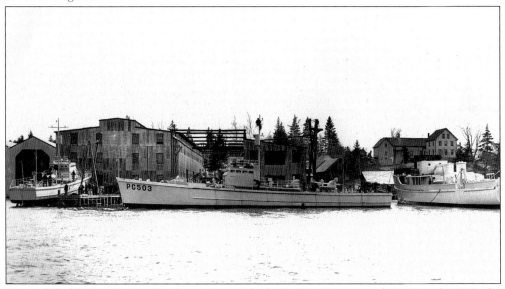

During World War II, Rice Brothers shipyard built 13 U.S. Navy vessels. In March 1942, the 110-foot subchaser PC504 was nearing her launch date. Her sister ship, PC503, is shown broadside. On the right is the 136-foot minesweeper YMS12 fitting out. Rice Brothers built marine engines and hundreds of vessels in wood, steel, and aluminum before closing in 1956. The site is now the Washburn & Doughty shipyard.

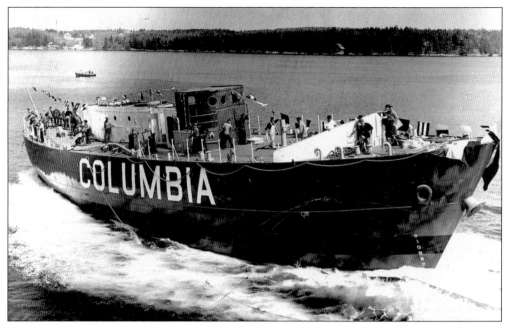

In April 1950, the Rice Brothers Corporation launched the 128-foot, steel-hulled lightship *Columbia* for the U.S. Coast Guard. A sister ship, *Overfalls*, would follow in May. The *Columbia* served her entire career at the entrance of the Columbia River Bar at Astoria, Oregon. Decommissioned in 1979, she is still in excellent running condition and is on the National Historic Register at the Columbia River Marine Museum.

The Paul Luke boatyard, on Linekin Bay in East Boothbay, is seen here in 1960. The 37-foot *Defiant*, one of 75 wooden boats Luke built from 1937 to 1987, is on the railway, ready for launching. Shifting to aluminum construction in the 1960s, Luke built 24 aluminum yachts and developed a large line of marine hardware. Paul Luke's son Frank runs the business today. (Courtesy of Frank Luke.)

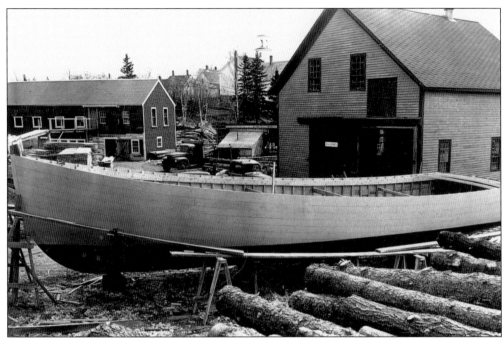

The 40-foot seiner *Judy J.* sits in front of the George Jones boat shop, with the East Boothbay tide mill and church in the background. The *Judy J.* was under build when George died in 1949. His sons J. Ervin and Neil completed her. J. Ervin fished her for a short while, then sold her to Red Bradley. (Courtesy of Jimmy Jones.)

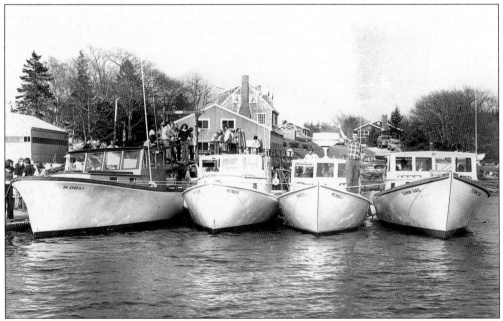

Seen here is the J. Ervin Jones Boatyard, off Murray Hill Road on Linekin Bay, in 1978. Jones-built boats lined up for the launching of the 34-foot lobster boat *Sunni Gale*, constructed for Phil Page. J. Ervin, waving from a Barlow design he built for Donnie Page, died in 1987 after 38 years of boat building. His son Jimmy Jones builds today at the same site. (Courtesy of Jimmy Jones.)

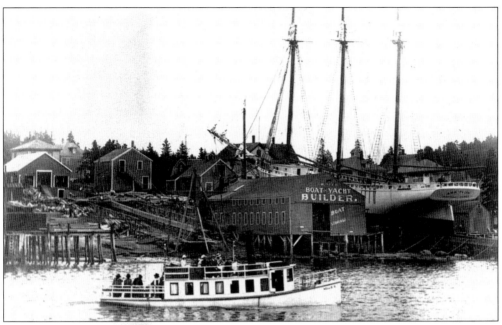

The schooner *Ada Cliff* is ready for launching in 1916 on Boothbay Harbor's east side. This yard was founded by Irving Reed in 1905; during World War I, called the East Coast Ship Company, it was briefly owned by Crowell & Thurlow. Reed bought the yard back after the war and continued to build until his 1934 death. His son Rodney Reed ran the business until 1966.

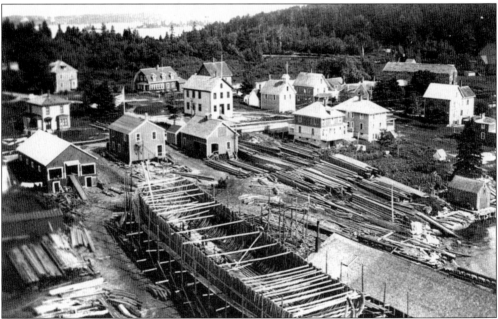

The schooner *Marguerite M. Wemyss* is in frame at the East Coast Ship Company, on the east side of Boothbay Harbor. This 168-foot four-master was launched in February 1919. Her career ended with a collision off Cape Lookout, North Carolina. Atlantic Avenue is in the background, with homes, a school and fire station with flagstaffs, and an icehouse. Linekin Bay is clearly visible in the distance.

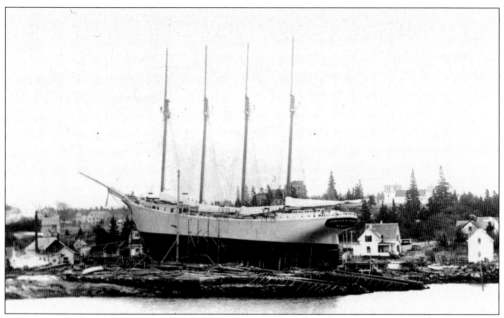

The *Josiah P. Chase* is ready for launch in January 1921 at the Atlantic Coast Company on McFarlands Point, now a condominium site. The wartime shipbuilding boom over, the *Chase* was the last large wooden sailing vessel launched in the country. She was laid up in West Boothbay Harbor in the early 1930s, was sold to Estonia in 1934, and ended her days carrying lumber in the Baltic Sea.

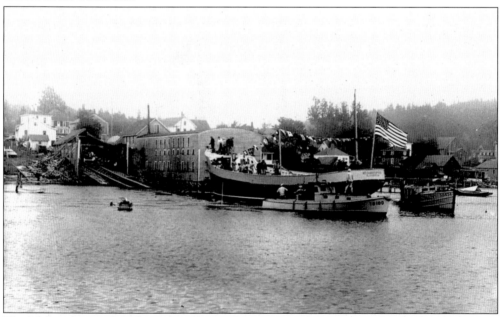

The 95-foot dragger *St. Christopher* takes to the water in July 1944 from the Reed yard, then run by Rodney Reed and his brother William, on Boothbay Harbor's east side. The shop she was built in was half dismantled for the launch. At the time, Reed was also building 38-foot buoy boats for the navy in the larger building to the right of the launching ways. (Courtesy of Linda Reed Farnham.)

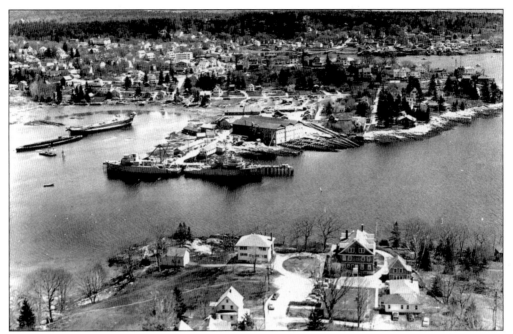

This spring 1957 view, looking east toward town, shows Frank L. Sample's shipyard in Boothbay Harbor. Floating dockside and fitting out are the 173-foot minesweepers MSO510 and 511. Sample's, founded by Frank L. Sample Jr. in 1939, built many navy vessels, as well as several draggers and small yachts, through the 1960s. The old St. Andrews Hospital complex is in the foreground.

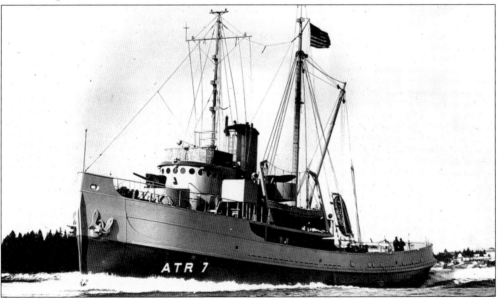

ATR7, a navy oceangoing rescue tug built by Frank L. Sample of Boothbay Harbor, is on sea trials in 1944. Sample's output during World War II included twelve 136-foot minesweepers and six 165-foot rescue tugs. Sample's was the former site of the Townsend Marine Railway, then the Atlantic Coast Company; this location is now occupied by condominiums and the Boothbay Harbor Sewage District.

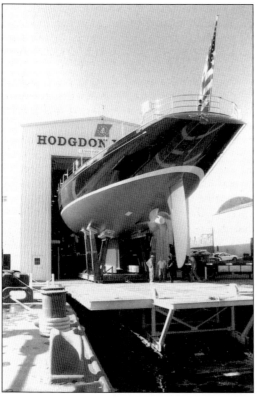

Shipbuilding continues in the Boothbay region. The 92-foot steel tug *Kaye E. Moran* (above), one of 15 tugs designed and built by Washburn & Doughty of East Boothbay, tests its pump in the Damariscotta River after its 2003 launch. This tug was built for the Moran Towing Corporation and will see service in the Chesapeake Bay. Washburn & Doughty is located on the former site of the Rice Brothers shipyard. The 154-foot ketch *Scheherezade* (left) moves out of her shed and awaits her masts, including the 185-foot mainmast, at Hodgdon Yachts in East Boothbay. The largest sailing yacht on the east coast, she was launched in September 2003 after four years of construction. (Above courtesy of Washburn & Doughty; left courtesy of Hodgdon Yachts.)

## Five
# COMMERCE

Besides the major businesses of fishing, carrying goods by water, and shipbuilding, Boothbay residents carried on the diverse occupations common to all towns. Some of those occupations were age-old, such as working at one of the area's 11 water-powered mill sites, some of which dated back to the arrival of settlers. Long-lived mills were the Dodge mill on Adams Pond, the Pinkham mill on Ovens Mouth River, and the Hodgdon mill in East Boothbay.

The small-home or village-industry model of self-sufficiency was reflected in the professions of blacksmiths, stoneworkers, cobblers, and tanners scattered around town before the Industrial Revolution. Much of the buying and selling relied on barter, so a blacksmith might be paid for a list of jobs, such as repairing plows, creating rudder irons, and shoeing oxen, with 50 pumpkins or a quantity of fish.

As time went by, the region became more prosperous and populous, and areas such as Boothbay Harbor, West Harbor, and East Boothbay developed into commercial centers with offerings more sophisticated than a general store and a few craftsmen. Millinery and jewelry shops coexisted with hardware stores and fishermen's supply stores.

The Industrial Revolution of the late 1800s brought factories to Boothbay. In addition to fish products, commodities processed on a large scale were bone and ice. From the 1870s to the early 1900s, almost all freshwater ponds in the region were ice-harvesting sites. It was a prosperous time for the region's laborers, with seasonally diverse jobs: cutting ice in deep winter, working on the farm and haying in the summer, and woodcutting and canning work in the fall.

Boothbay Harbor emerged as the largest center in the region, with much of the vibrant commerce located there, though there were unique businesses elsewhere, such as the Boothbay Medicinal Spring in East Boothbay. With the coming of the tourist era in the 1880s, the sidewalks became cheerful and carnival-like, with street vendors attracted by the busy villages.

Many stores became fixtures in the towns, both in the winter and in the summer. Stores that offered universally needed basic goods—fuel, hardware, drugs, clothing, and food—had steady traffic over the years, until easy transport to shopping centers in the mid-1900s drained part of the commerce. Yet modern counterparts continue to fulfill the constant local need for certain commodities.

East Boothbay's millpond has been a tide mill site since the 1600s. The Hodgdons ran a mill there, as seen above, from the 1820s to the 1940s. Incoming tidal water forced the mill's doors open and filled the pond. As the tide ebbed, the outgoing water's force shut the doors and trapped the water, which was directed to a water wheel or, after 1870, a turbine. The mill was a sawmill and, at times, a gristmill. Above, the 1920s wintry scene shows that logs have been run under the mill into the pond from the river. Saw logs were drawn into the mill up the ramp on the left. The mill was torn down for road widening in 1959. Below, Tyler Hodgdon, the last Hodgdon owner of the tide mill, and a c. 1910 crew cut wood for the mill.

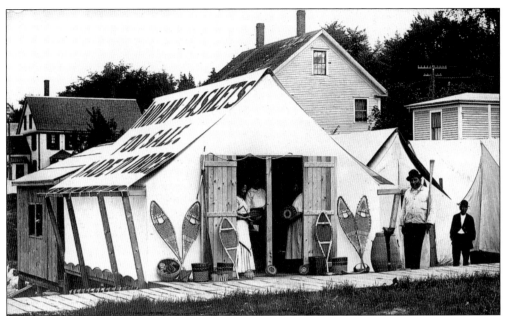

From the beginning of the tourist era in the 1870s, families of American Indians, including the Rancos and Sockabasins, came to Boothbay in the summer to sell their wares, principally baskets. Also popular were "war clubs," made from alder roots, carved paddles, and snowshoes, as seen in the above photograph. Normally, the families came from the Indian Island reservation at Old Town. Above, the Sockabasin tent, once a familiar sight, appears at the east end of the footbridge in Boothbay Harbor c. 1915. The family stayed at that location for many years, occupying Harold W. Bishop's lawn, and Bishop adopted one of the children. Below, a Sockabasin girl sits in a basket for the camera.

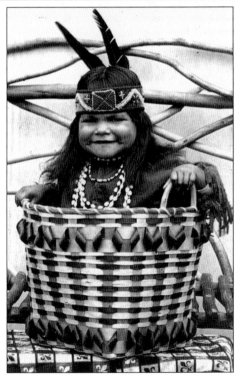

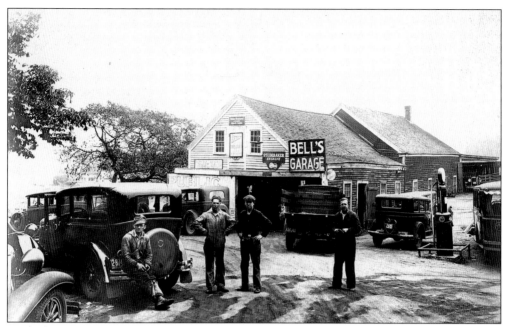

With the popularity of cars came the need to service them. Some stables converted to garages, but they were outnumbered by the many new 1920s garages devoted to automobiles. Seen here c. 1931 is Bell's Garage, below Townsend Avenue on the harbor's waterfront. Pictured, from left to right, are employees Wendell Barlow and Cecil Pierce, owner Vance Bell, and employee Lawrence Lewis. The building was demolished in 2003.

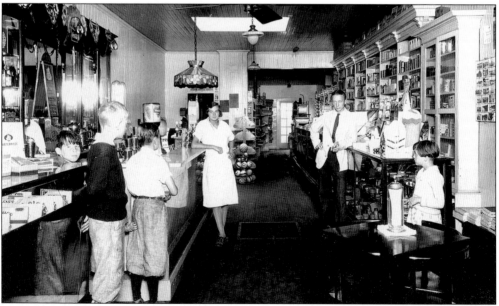

Porter's Drug Store, founded in 1893, was a Boothbay Harbor fixture for about 100 years. Its enduring "upper" site, seen here c. 1930, was on Townsend Avenue, but it also had a "lower" Commercial Street store. Pictured, from left to right, are Luther Reed, Francis Greene II, Bertrand Rowe, clerks Ruth "Puss" Farnham Witham and Raymond "Spider" Tibbetts, and Ivern P. Farnham.

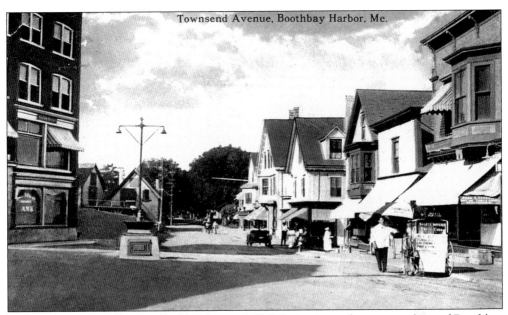

Wiscasset native William Willard, nicknamed "Bill Bailey," was the popcorn king of Boothbay Harbor from c. 1910 to his 1930 death. He appears here c. 1925 in Bank Square on Townsend Avenue, just east of the horse trough. As a mobile sidewalk merchant, he pushed his cart and peddled his popcorn. His song was, "No old maids in my popcorn, five cents a bag till it's all gone."

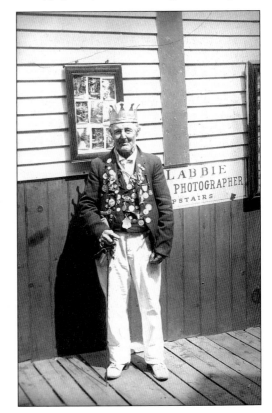

A harbor character of the early 1900s was "King Stewart," seen here on Commercial Street c. 1915 wearing gold shoes, holding a sword, and bedecked with medals. Johnny "Professor" Stewart was from Barters Island and worked as a stable hand, often sleeping in barns or attics. People gave this familiar figure the medals and pins with which he covered his clothes. He died in 1922.

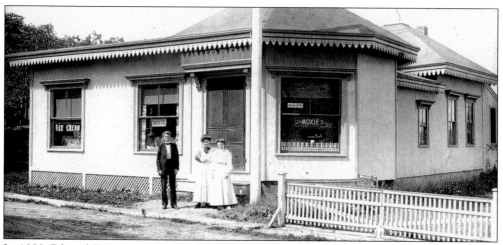

In 1882, Edward E. Race of East Boothbay decided to turn a local well, long unused because of the water's high mineral content, into a profitable medicinal destination, much like those resorts where people went to "take the waters." He built a charming building to enclose the well and installed a soda fountain for people with more sugary tastes. While never a success, the well evolved into a drug store, which became a commercial fixture on the main road in the village until the 1960s. Posing above *c.* 1905 are, from left to right, Race's children Jamie and Nellie and neighbor Dorothy M. Hodgdon. The 1880s logo pictured below decorated all the bottles. The building is now a private home.

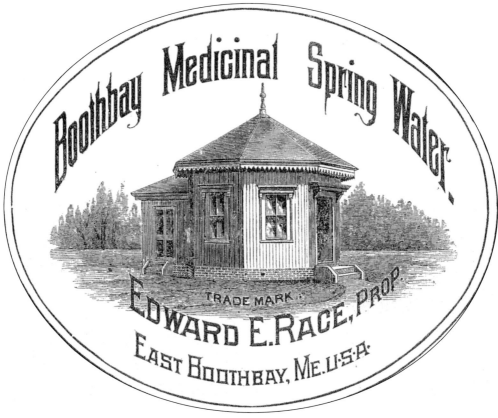

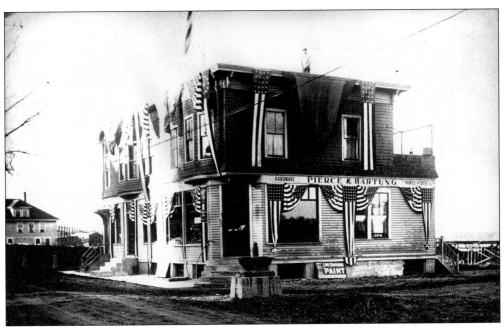

Pierce & Hartung was a hardware and building-supply business on the harbor's main east-side road, Atlantic Avenue. Above, the business is decorated for the 1919 Welcome Home parade following World War I. Starting as a coal and stove-wood business in 1891, Pierce & Hartung was purchased by Clayton Dodge in 1954, finally closing in the early 1980s. It is now the site of the Rocktide Inn. Below, three trawlers are tied up at the coal dock in the late 1940s. Of them, the 1940-built *Notre Dame* was the first boat-building job that Jim Stevens, longtime owner of the Goudy & Stevens shipyard, supervised for another yard. Irving Reed's shipyard is on the right.

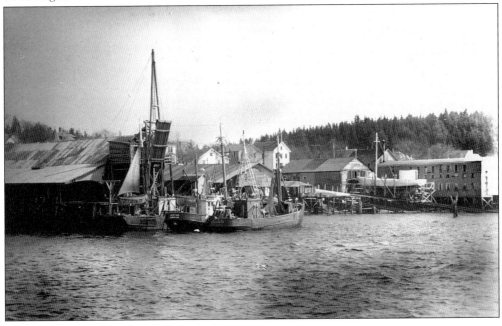

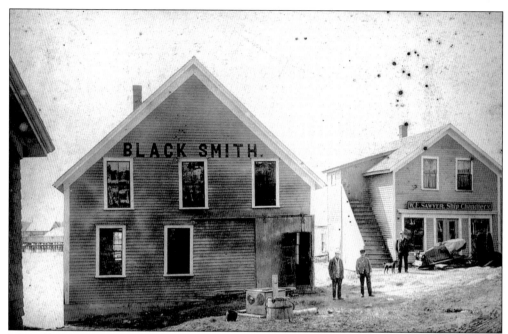

Many blacksmiths set up shop in Boothbay Harbor. Late in the 1800s, Alden Winslow moved to town and did ironwork on the lower end of Commercial Street, near Billy Sawyer's wrecking business and chandlery, seen here c. 1910. Albert Eames acquired the business c. 1915 and maintained his shop for a few decades.

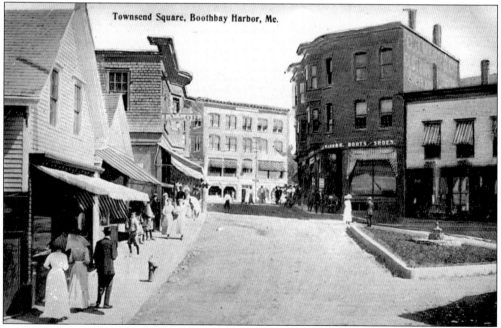

A prominent presence on Wharf Street in Boothbay Harbor was the customs house, which cleared vessels and gathered their duties. Built in 1885, it is seen here c. 1910 on the far right; it is now a gift shop. In 1907, the customs office moved into the bank (the 1906 brick building with awnings). The customs office was finally discontinued in 1944.

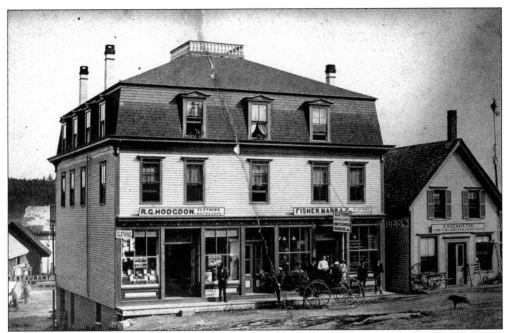

In this c. 1885 view, stores in Custom House Square provide basic necessities for Boothbay Harbor residents. The mansard-roofed Lewis Block, built in 1883 by Isaiah Lewis, housed the Hodgdon and Fisher & Marr clothing stores. Below is Kenniston's furniture and undertaking shop. The Lewis Block is now the site of the Village Market, and Kenniston's is now the Smiling Cow.

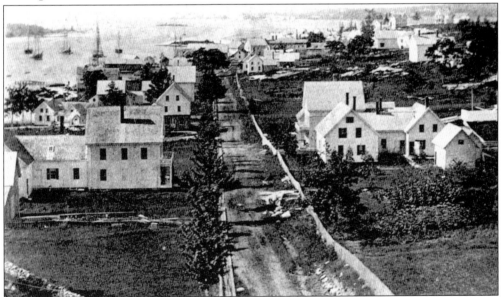

This 1885 view of the intersection of Pear Street and Townsend Avenue in Boothbay Harbor was taken from the Congregational Church steeple. Townsend Avenue appears nearly vacant compared to its present high density of buildings. The fencing along the avenue implies that livestock ownership was still common, and the fencing in or fencing out of the critters was still standard.

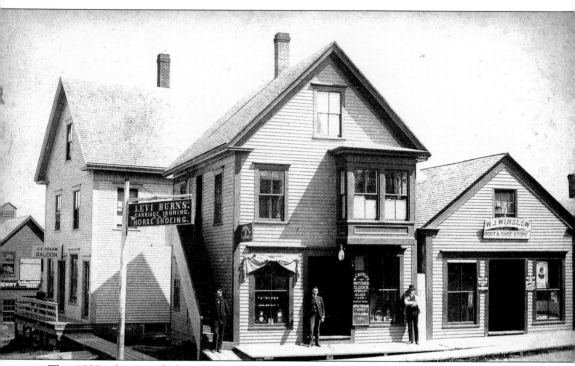

This 1890s photograph describes well the typical businesses in a good-sized town before malls, cars, and paved roads. On the left is Pask & Kenney's stable on the Byway, and a sign points to Burns's blacksmith shop. The stable is now the site of the bowling alley. The next building is W. F. Dudley's jewelry, watch, and eyeglass store, a Townsend Avenue business dating to 1885; the owner appears in the doorway. The back part is now the office of Harold W. Bishop. Adjoining Dudley's is the Fisher & Marr clothing store. Next is W. J. Winslow's shoe shop. Later, Dudley's moved north half a block to the site of the current jewelry store, A Silver Lining; Fisher & Marr moved too, half a block south to the current site of Paine's clothing store.

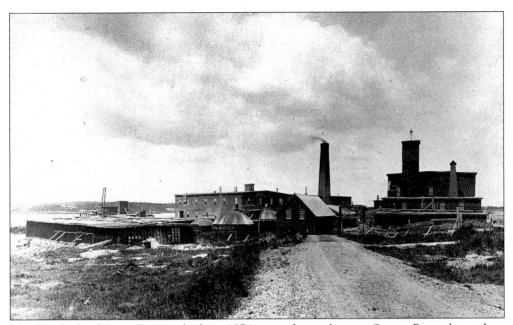

The Cumberland Bone Factory, built in 1874, was a huge plant on Spruce Point, located on Boothbay Harbor's east side. The plant produced fertilizer from fish and animal bones, brought from as far away as Europe. When the factory was torn down in 1908, the chimney was left standing for a few years as a mark for seafarers navigating along that stretch of coast.

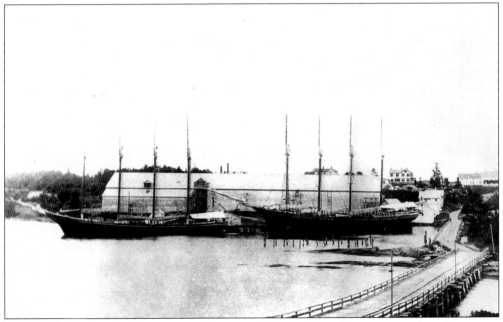

The Knickerbocker Ice Company, with many facilities along the eastern seaboard, came to Boothbay in 1876 and developed Campbells Pond into the Knickerbocker ice pond. The associated icehouses were located on the Sheepscot River shore opposite Hodgdons Island. The icehouses seen here were rebuilt in the 1880s following a fire and were finally demolished in 1921. The four-masters are likely the *Mt. Hope* and *Charles Schul*.

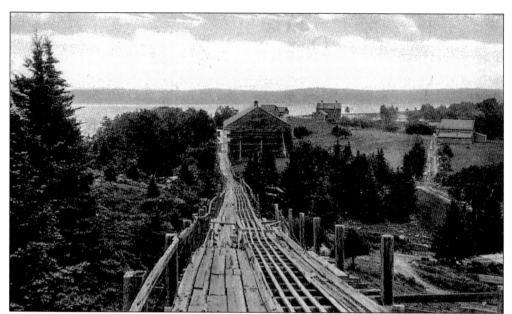

This East Boothbay ice works may have been the first in the area. Robert Montgomery and others organized the Boothbay Ice Company in 1871 to harvest ice at Reed's Meadow at Meadow Cove. This c. 1905 photograph shows the track that carried the ice from the pond and along the cove to the icehouses near deep water. The pond's owner, Levi Reed, made sure his rights to cranberries and hay were protected.

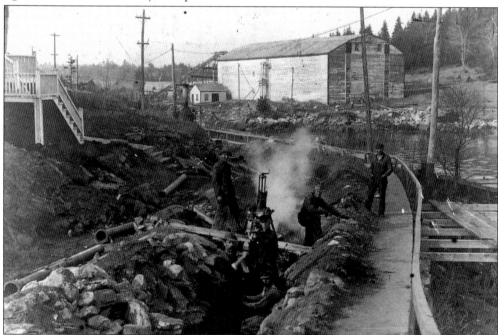

The meadow north of Mill Cove was often dammed in its long history. The last time was in 1882 by Luther Maddocks for ice harvesting; the dammed meadow was renamed Penny Lake. Seen here in 1912 is the icehouse and the steel elevator that carried ice into the building; the lake is behind. In the foreground, Elbridge Giles's crew blasts the water main to West Harbor.

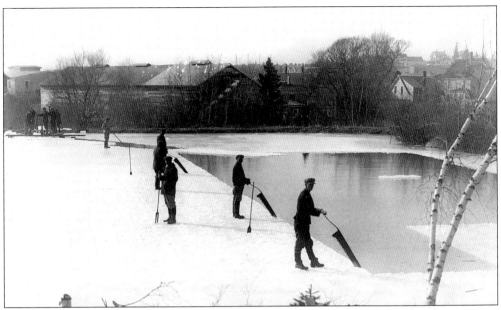

Pat's Pond, on Boothbay Harbor's east side, was a small ice-cutting pond. Once the ice was a foot thick, operations could begin. Horse-drawn groovers have scored the ice in this 1908 photograph, and men cut and handle the blocks with ice saws, picks, and chisels. In the background, the blocks are carried up the elevator into the icehouse, where they are insulated by sawdust or hay.

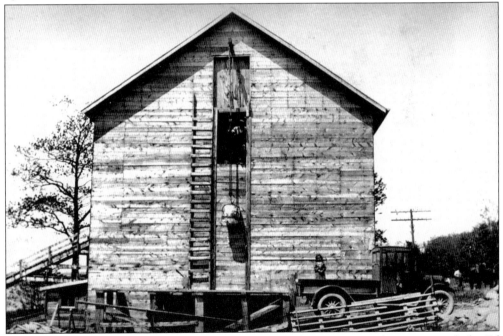

The ice works at Adams Pond, small by local standards, was operated intermittently by Ed Spinney up to 1950. The icehouse was located halfway up the pond, on the west side of Route 27. Here, in the mid-1920s summertime, Spinney lowers an ice cake down to a platform to be slid into the body of a waiting truck occupied by his helper, daughter Muriel.

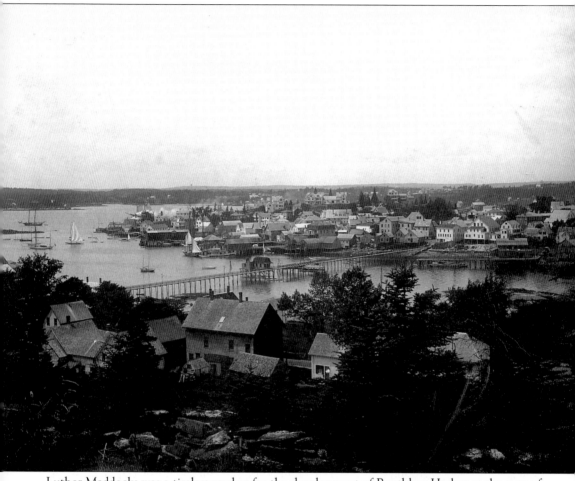

Luther Maddocks was a tireless worker for the development of Boothbay Harbor at the turn of the last century. He ran multiple fish factories and ice works, employing hundreds of local people. He worked in the Maine legislature to improve fish laws, and in Washington to benefit Maine. In the 1880s, Maddocks and other businessmen campaigned for the separation of Boothbay Harbor from Boothbay in order to maximize the harbor's potential as a commercial center. The bitter division of the towns came in 1889. He underwrote harbor amenities, such as the 1901 footbridge connecting both sides of the harbor (seen here c. 1915), the opera house on Townsend Avenue, and the fountain in Custom House Square. He introduced a luxury we now see as a necessity: electricity. A railroad for the Boothbay region was his only venture that never transpired.

# Six
# COMING TOGETHER

Just as Yankee ingenuity played an important role in the workday lives of Boothbay region residents, so did it figure into the region's playtime. For instance, who would expect to find in the historical society archives a photograph of a roller coaster in East Boothbay c. 1910? But it does exist: a postcard that shows a festive group seated on a roller coaster car sliding down a track behind the (still-existing) corner store.

Much of the entertainment in past days took place outdoors: patriotic parades on Memorial Day and the Fourth of July and lobster- and clam-eating festivals drawing hundreds of local people as well as visitors. There were local twilight baseball games, hayrides, picnics, boat shows, and beauty contests. The Walter Buzzell Health and Sports Complex on Back Narrows Road offered a pool, tennis courts, a gymnasium, and annual swimming and diving competitions in the mid-1900s. In winter, roads turned into tracks for sledding, and ponds became ice-skating rinks and horse- and car-racing sites. Boating, in all its forms, was a major source of enjoyment.

A large number of fraternal and other organizations drew their members together for events indoors and out, among them veterans groups, Knights of Pythias, Masons, and firemen (who put on musters). Many groups had ladies' auxiliaries that held fairs and bake sales to raise money. The now-extinct Monday Club provided social and intellectual stimulation for its all-female membership.

Theater groups proliferated—from minstrel shows that drew on local talent to spectacles at the opera house and the mid-1900s Boothbay Playhouse. Several Boothbay region neighborhoods had halls providing venues for dances, pot lucks, and other social events. Similarly, the summer colonies had casinos for their events. Movies came to Boothbay Harbor with the construction of the Strand Theater in 1927 (it burned down in 1981) and the production of *Carousel*, filmed partially on Boothbay Harbor's east side in the 1950s.

There was never a lack of things to do in Boothbay, both for the tourists pouring into the region (whether by car or by steamer from Bath, Portland, and Boston) and for the local residents taking a day off from the chores at hand.

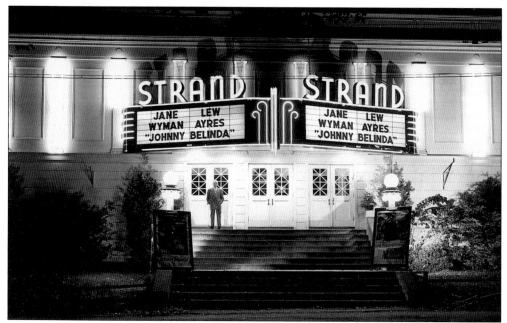

Saul Hayes, on the Strand Theater steps in 1948, provided places of entertainment in the region, such as dance halls and casinos. He built the Strand on Boothbay Harbor's Townsend Avenue c. 1927, next door to the opera house. Talkies came to the Strand in 1929 with a first-night audience of 1,100. The theater endured until it was destroyed in an arson fire in 1981.

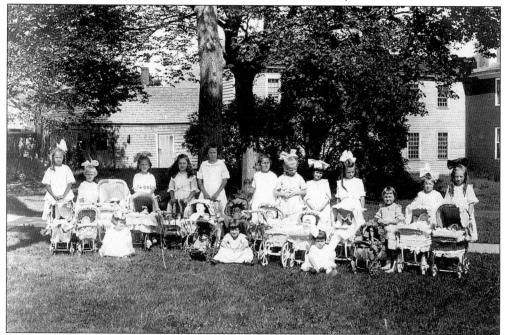

In August 1922, the Boothbay Harbor Memorial Library committee, with 100 volunteers, organized a fair to raise funds to remodel an Oak Street house into a library. The attractions were exhibits, a fortuneteller, booth sales, a band concert, a tableau, and a doll-carriage parade. Harbor girls within walking distance took part, and they are shown in front of the Brick House.

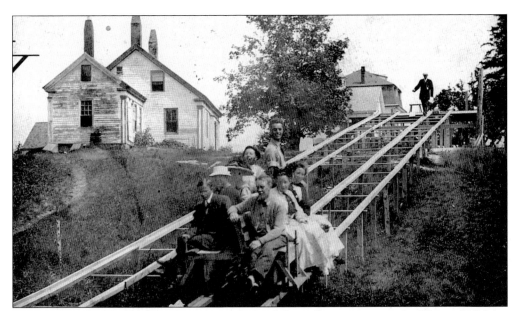

In 1910, boat-builder Freeman Murray constructed this roller coaster near his Murray Hill boat shop (marked by the staging bracket on the left) and the corner store (at the top of the track). A woman named Myra wrote on this August 25, 1910, postcard, "We sampled Mr. Murray's roller coaster at East Boothbay and just then the photographer from Boothbay Harbor came along and took our pictures. It was lots of fun."

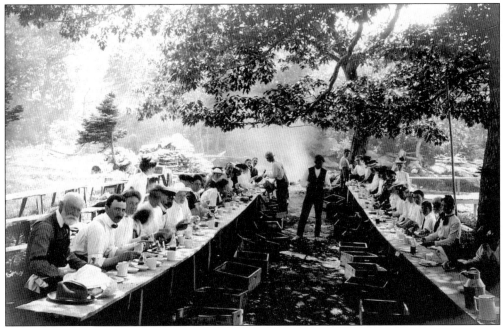

Capt. Freeman McKown's traditional clambakes at Oak Point in Boothbay Harbor lured tourists and locals alike to yummy seafood feasts during the early 1900 summers. The long-gone Oake Grove Hotel, among others, organized special outings for guests to go to the clambakes. Attendees were served at long wooden tables and could toss their shells in boxes lined up in front of the tables.

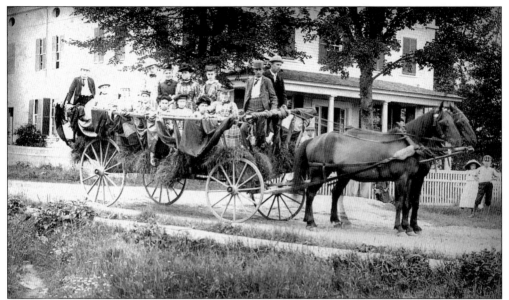

Hayrides were fun for all ages at the turn of the last century. Here, in front of the old Weymouth House c. 1900, is a hay wagon filled to capacity and drawn by a handsome pair of horses. In the right background are a wistful-looking pair, who apparently arrived after the wagon was full. They will just have to wait for the next ride.

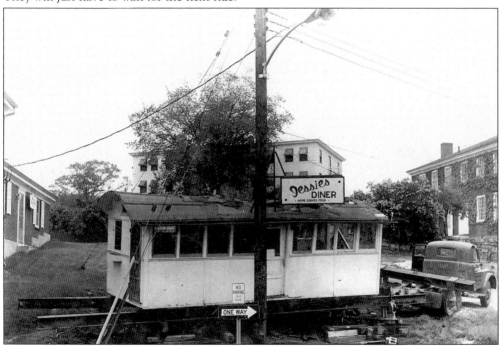

In this late-1960s view of Boothbay Harbor's Townsend Avenue, Jessie's Diner is moved to the Railway Village grounds, where it became a period piece. The diner, first Mac's (Reginald McTigue), then Etta's (Etta Dunton), and finally Jessie's (Jessie Mahr), had stood on the Townsend Avenue site since 1938, after being moved from McKown Street. It was a favorite, particularly during World War II, of Sample's shipyard workers.

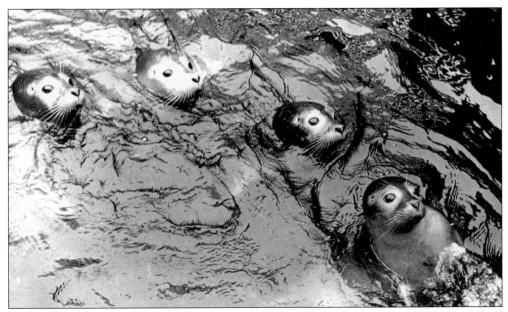

Since 1915, a public aquarium has been maintained at the hatchery, first by the federal government and later by the state. In the early 1930s, it became the custom each spring to collect baby seals to exhibit, and these eventually became the most popular features of the aquarium. In 1972, however, the terms of the new Marine Mammal Protection Act were so stringent that the exhibit became impracticable.

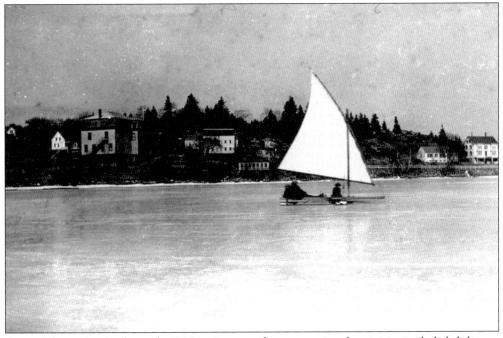

Around the region in the early 1900s, winter outdoor recreational activities included sliding, a little skiing, skating, and ice boating. Here, on the millpond in East Boothbay, an iceboat sails by the Community Union Hall and the houses on the north side of the pond. No doubt the ice boaters avoided the mill area, with its twice-daily flow of tidewater thinning the ice.

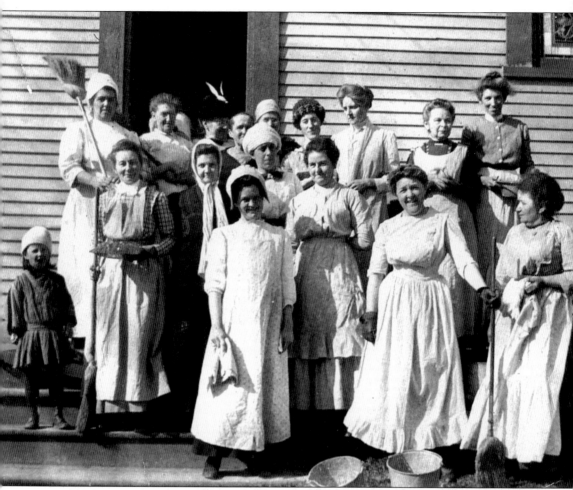

The Ladies Aid of the East Boothbay Methodist Church poses in 1912, having cleaned the building and installed a carpet. The church was erected in the 1830s on Barlows Hill on the north side of the village and was moved in 1863 to its current location on Church Street. Pictured, from left to right, are the following: (first row) Eva Race, Isabel Montgomery, and Etta Barbour; (second row) young Audrey Genge, Gertrude Vannah, Alida Seavey, Jennie Carver, and Mary Fuller; (third row) Lizzie Seavey, Ellen Jones, Lizzie Race, Priscilla Farnham, Nina Murray, Mrs. Genge (the minister's wife), Ida Dodge, Olive McDougall, and Julia Van Horn.

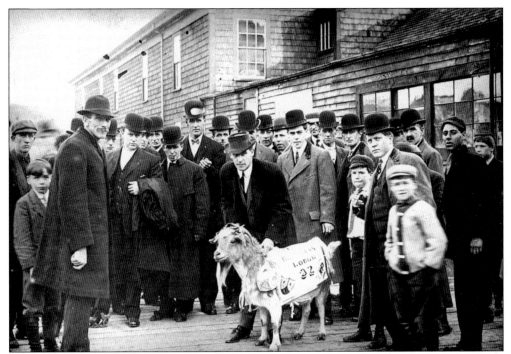

The Boothbay Knights of Pythias Lodge No. 32 was organized in 1882. In this c. 1910 photograph, Boothbay lodge members, dressed for an occasion, prepare to board a steamer. Accompanying them is their goat, wearing his best coat. The goat's role in the lodge's initiation and rank rituals is unclear, but the camera's focus implies he is a key figure.

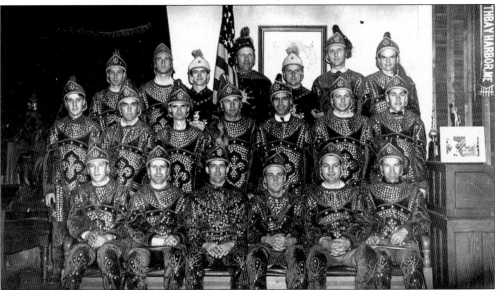

The Knights of Pythias, posing for an April 1948 photograph, are, from left to right, as follows: (first row) George Hume, Albert Lewis, Wolcott Webster, Austin Dolloff, Winston Buzbee, and Richard McDougall; (second row) unidentified, Merlin Barter, Clinton Jones, George Reed, Louis Paine, unidentified, and Brud Pierce; (third row) Herman Pinkham, unidentified, James Murray, Alton Dickinson, Gordon Lewis, Gordon Harrington, and Clinton Hutchins.

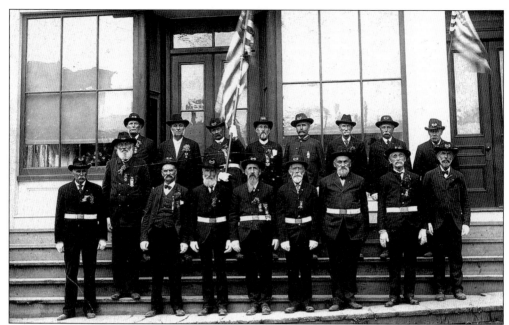

The Misses McKown Millinery stood on the northeast corner of the library lawn until 1934, when it was moved south down McKown Street. Built in 1879, the shop was often the backdrop for members of the Grand Army of the Republic, who gathered for a photograph following the Memorial Day parade. The Civil War veterans, now reaching old age, pose c. 1910.

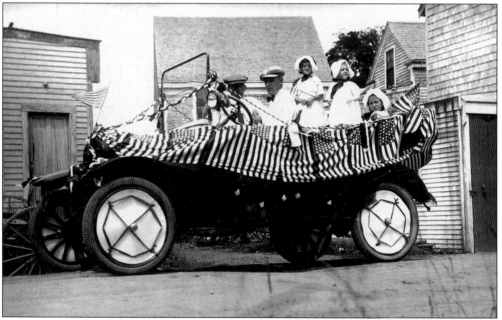

This merry crew is all dressed up for the 1928 Boothbay Harbor Fourth of July parade. Ready to travel in their bunting-bedecked open "convertible" are, from left to right, Bill Simpson, Harry Thomas, Genevieve Thomas, Helen Simpson, and Mary Thomas. Patriotic parades continue in Boothbay, focused primarily on Memorial Day, when the parade travels to several different regional points.

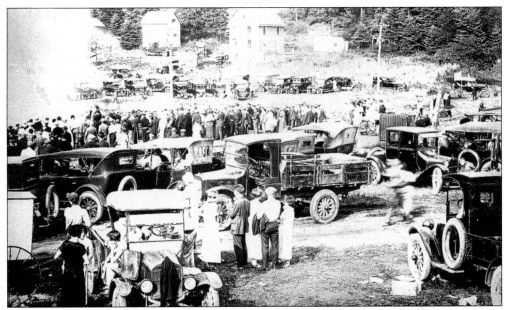

The c. 1910 Veteran Firemen's Muster drew huge crowds and the latest in horseless carriages to the old ball field off Sea and Commercial Streets at McFarland Point in Boothbay Harbor. The people could admire each other's vehicles as well as what appears to be an early version of a fire truck (center). By 1916, Boothbay Harbor had advanced to a $1,400 La France motorized chemical fire engine.

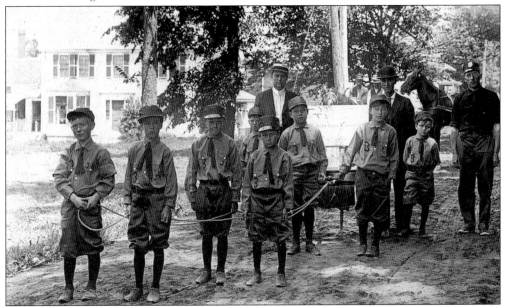

In the second decade of the 20th century, the boys of West Harbor Junior Hose Company No. 3 competed against the harbor's east-side boys. The junior fire brigade, consisting of boys 12 and under, had their own hose cart, hose, and firefighting equipment. Seen here, from left to right, are the following: (boys) Donald Giles, Merrill Barter, Carlton McKown, Ernest Pilman, Houghton Orne, Bud Barter, Alan McMillan, and Luther Greenleaf; (men) Ed Hutchinson, Frank Moore, and Harry Thomas.

The 1947 and 1948 Fisherman's Fair, sponsored by the East Boothbay Chamber of Commerce, drew thousands to the village to "the biggest clambake on earth." The festival featured shipyard exhibits, boat races, carnival rides, and a beauty contest. The 1947 Fisherman's Fair float (above), using the Clifford's Seafood Market truck, gets its finishing touches in the village shipyard and market area. From left to right, neighborhood boy Alan Lewis and twins Albert and Alfred Dodge arrange traps and oars inside the dory while George Rockwell paints the back. Clifford's is now the site of Lobsterman's Wharf in East Boothbay. Serving the three tons of lobsters at the 1947 fair were, from front to back on the left side of the table, Jim Stevens, Evelyn Stevens, Francis Dodge, Richard "Pie" Lewis, and Althea Lewis. Picnic tables ran the length of School Street.

Walter Buzzell, a gymnast on the theater circuit, founded Buzzell's Health Farm at Back Narrows in 1932. He provided a saltwater swimming pool, tennis courts, ball grounds, a solarium and gym, changing rooms, and, sometimes, a restaurant. Picnic areas and fireplaces made it a destination for family get-togethers and group activities. It served for many years as the YMCA before finally closing c. 1980; it is now a private home. In its heyday, the farm held carnivals featuring aquatic and gymnastic contests and vaudeville shows. Above, people swarm the ledges to view the competition. At right, a diver takes off from the highest board during the carnival.

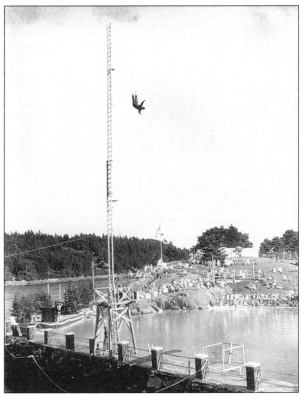

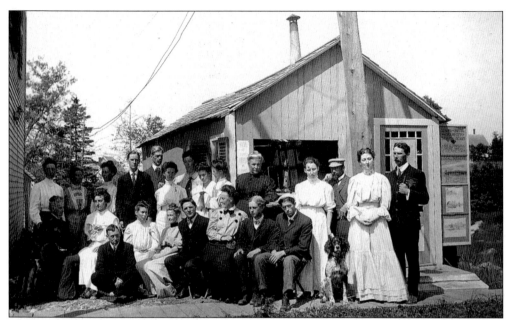

Teachers and students at the Asa Randall Studio were part of the local art scene of the early 1900s. Several art schools sprang up in Boothbay then, drawing hundreds of students to the region to live and study in the summer art colonies. The Boothbay Region Historical Society has several paintings from the colonies, as well as an extensive collection of memorabilia from those creative seasons.

Cast members of the Monday Club's 1943 presentation of *The Hardscrabble Uplift Club*, an original farce written by local historian Elizabeth Reed (far right), line up for their performance in the Methodist church vestry. The Monday Club, organized in 1895 to foster social and intellectual exchange, flourished until the 1990s. The club's headquarters, Reed's home, is now the site of the Boothbay Region Historical Society.

*Arsenic and Old Lace,* performed at the Boothbay Playhouse, was a highlight of the Little Theatre Group's 1953 season. Pictured, from left to right, are Richard Valentine, Jean Glude, Richard Graef, Ernest Coombs, Peggy Hammond, Ross MacClure, Kay Lewis, and John Glude. The Little Theatre Group, consisting solely of local residents, was formed in 1950 and usually performed at the opera house. Proceeds went to community-betterment projects.

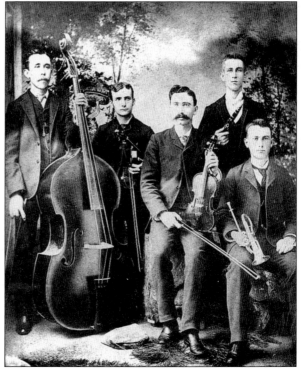

Music in a sylvan setting was the order of this day for members of the Boothbay Harbor Orchestra. Posing for this c. 1910 photograph are, from left to right, Lincoln Harris, bass; Charles Kenniston, violin; Henry Wylie, violin; Franklin Dolloff, flute; and Joseph Jackson, cornet. The local orchestra at times played musical accompaniments for silent movies and performed in vaudeville shows.

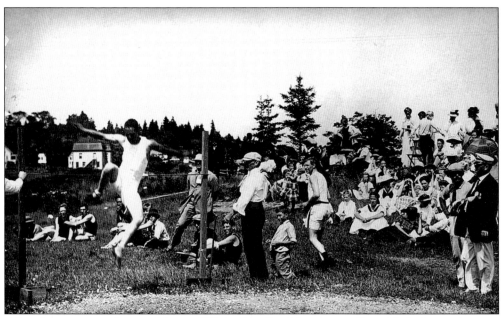

After the summer colony at Murray Hill in East Boothbay was well established, a casino was built, which briefly became the headquarters for the Linekin Bay Yacht Club in 1912. In the same year, the organization sponsored Fete Days at Murray Hill. Attendees could compete at the carrying place in such feats as high jumping, shown above. In this photograph, the Community Union Hall is north across the pond. As seen below, barrel racing involved emerging from a barrel; in a variation, participants ran inside barrels while scantily dressed. Swimming events took place near the steamer landing at Murray Hill, and boat races were held at the casino waterfront site at the end of Murray Hill Road.

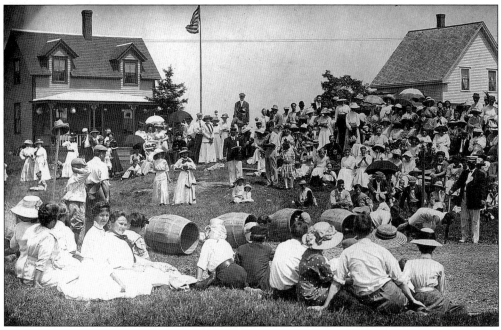

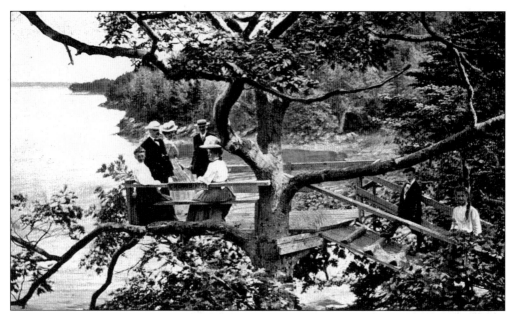

The Crow's Nest, once located near Barrett Park at Lobster Cove, was a popular tree house site for picnics and relaxing in the early 1900s, as was a treetop observatory at Sprucewold. There were also local recreational towers for vista viewing in the early 1900s at Little River and Mount Pisgah. Towers of that period used for more solemn purposes were signal-flag towers for vessels and wartime spotter towers.

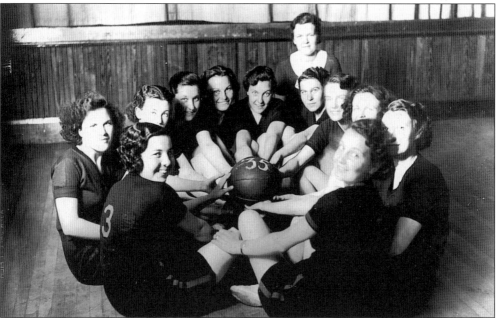

The 1934–1935 Boothbay Harbor High School girls' basketball team huddles for a photograph. Pictured clockwise, starting with No. 3, are Pauline McDougall Linekin, Verona Paine Douglas, Adda Bell Orne, Phyllis Pinkham Murray, Margaret Orne Kelly, Nancy Hallett Woods, coach Miriam Wheeler, Carmelita Dickson O'Keefe, Cleo Rowe Lewis, Bertha Seavey Bean, Alice Jellison, and Shirley Dickson Coombs.

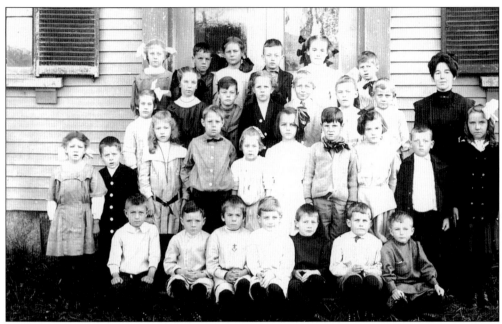

Above, East Boothbay students gather for a photograph c. 1915. Included are familiar village names: Dodge, Barlow, Rice, Hodgdon, Farnham, Adams, Van Horn, Bryer, and Chapman. Superintendent Harold Clifford arranged to have all the region's classrooms and students photographed in 1938. Below is one result. East Boothbay students sitting at attention are, from left to right, as follows: (first row) Robert Barlow, Glen Dodge, and Freddy McKown; (second row) Muriel Tibbetts, Robert Hyson, and Betty Alley; (third row) Charles Spear, Carolyn Rice, J. Ervin Jones, and Gordon Adams; (fourth row) Richard Blake, Richard Powell, Gordon Pottle, and Emma Dodge; (fifth row) Evelyn Pottle, Patsy Adams, and ? Powell; (sixth row) teacher Pearl Hinton and unidentified.

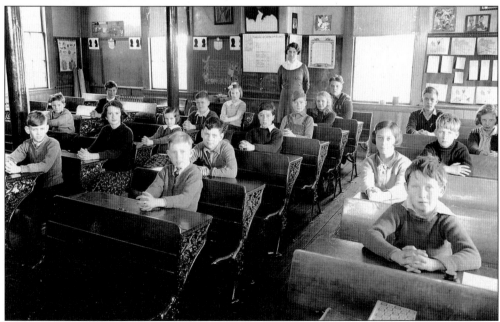

# Seven
# SUMMER COMMUNITIES

"The tide of summer travel commenced to set in toward Boothbay" soon after 1870. At first, summer visitors, mostly from inland Maine towns, camped out or stayed in boardinghouses or private homes. By 1906, however, when Francis Greene penned those words in his *History of Boothbay, Southport and Boothbay Harbor, Maine,* 10 hotels were located in the region, accommodating from 50 to 150 visitors each, and many summer colonies had begun to thrive. Almost all visitors arrived by steamboat, and many stayed all summer.

Developers bought large, unpopulated tracts, unattractive or unnecessary to year-round residents, and created summer colonies. Well established by the early 1900s were colonies at Squirrel Island (115 cottages), Ocean Point (70), Bayville–Murray Hill (36), Capitol Island (30), and the Isle of Springs (25). Typically, each colony began when a few families from elsewhere in Maine—Auburn and Lewiston in the case of Squirrel Island, Augusta and Waterville in the case of Ocean Point—bought land and sold (or sometimes gave) lots to friends and others from their home communities. Most colonies formed associations to manage community affairs and to negotiate with the towns to obtain roads and other services. The lively summer communities that evolved include such amenities as tennis courts, swimming and sailing programs, and, most importantly, community halls or "casinos," which became and remain an important locus for summer social activities.

Additional summer communities developed in the 1920s, hastened in some cases by electrification. Among them were Appalachee, Boothbay Shores, Pratt's Island, McKown Point, Pine Cliff, and Sprucewold. In the early decades of the 1900s, the concerted effort to develop certain colonies was complemented by older established communities, such as Linekin, Juniper Point, and West Harbor, that were slowly incorporating a large summer population.

While the Depression and World War II stalled growth in the 1930s and 1940s, "the summer trade," as it was early called, began to recover in the 1950s and continues to expand. The development trend continues wherever tracts of shorefront become available; recently such subdivisions have spread along the Damariscotta River and Newagen. As summer colonies reach capacity, year-round homes are being bought from the local population or built as second homes by people "from away." Another recent phenomenon is the transformation of summer people into year-round residents, as people with long-term summer connections to the region move here permanently following retirement.

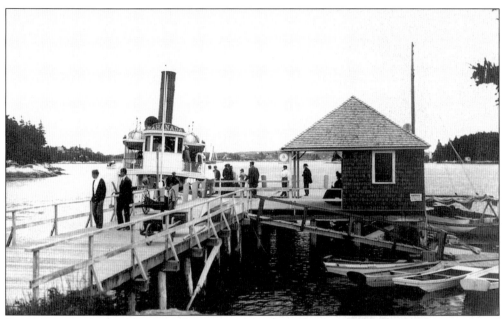

Steamers were the main means of transport for many decades. Pig Cove Island was renamed Capitol Island (above) when it became a summer colony in 1878, probably as a nod to its new residents, most of whom came from the Augusta region. Unloading is the steamer *Nahanada*, one of the longest-running local steamers, which sailed the Bath-Boothbay route from 1888 to 1925. Since 1938, a narrow bridge has linked Capitol to the Southport mainland. The steamer wharf on Squirrel Island (below) is a festive place in this *c.* 1915 photograph. Perhaps boat races or tennis matches have created the excitement and drawn the crowds. The summer colony islands were particularly reliant on steamers for transportation, and they still rely on passenger boats that make frequent runs to the islands.

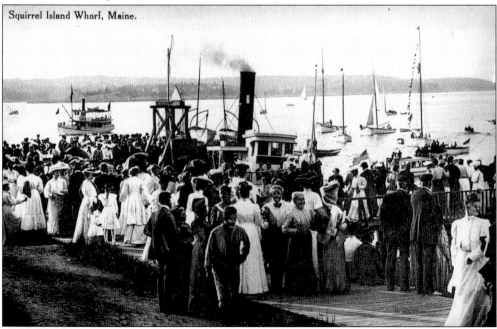

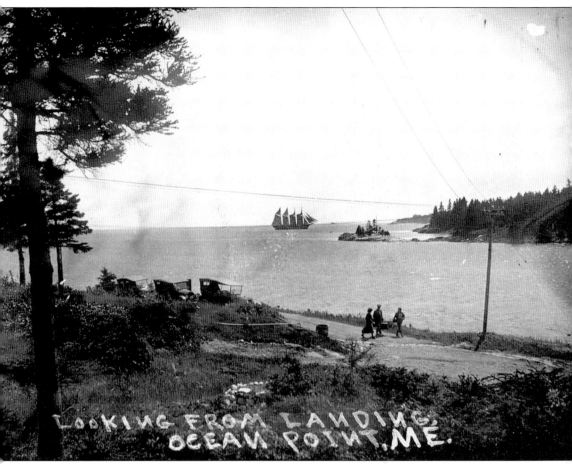

Taken c. 1916 from near the steamboat wharf, this photograph captures Ocean Point's essence then and now: panoramic ocean and island views and summer visitors driving or strolling along Shore Road. The dark area on the right is Negro Island, with the tip of Squirrel Island visible behind it. Contrary to one theory, Negro Island was not so named because of its involvement in clandestine efforts to help slaves escape to Canada in the 1800s. Like the White Islands and Green Island on the west side of Ocean Point, Negro Island is so named for purely descriptive reasons: it is the dark, or black, island marking the east entrance to Boothbay Harbor for fishermen and others, including the crew of this four-masted schooner about to enter Boothbay Harbor.

Begun on a small scale in 1894 by W. H. Reed, the Oake Grove Hotel in West Harbor underwent several expansions, and by 1915 it offered its guests 150 rooms, as well as concerts, boat excursions, and a host of other activities. Three Reed generations ran the Oake Grove until its razing in 1965. In 1971, the region's first condominium complex was built on the property.

The Weymouth House was built in 1848, and its builder and owner, John Weymouth, operated it as a hotel until his death in 1880. Razed in the 1920s, it was replaced by the Hotel Gara. Under successive owners, Hotel Gara became the Hotel Fullerton and, in 1950, the Village Inn. The building was torn down in 1969, and the site is currently occupied by the Boothbay Harbor Post Office.

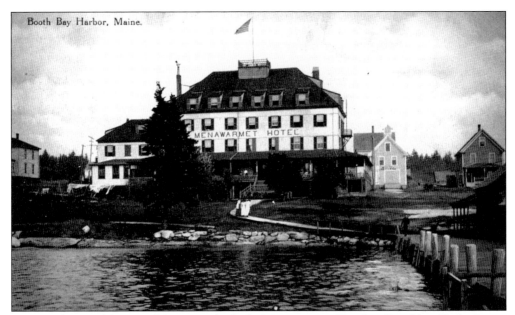

In 1889, the Boothbay Land Company built the Menawarmet Hotel on Boothbay Harbor's east side to house tourists and prospective buyers of summer cottage lots. The company bought thousands of acres in the region to develop. The hotel, named for an American Indian chief who lived in the early 1600s, burned in 1913. An Atlantic Avenue law office is currently housed at the location.

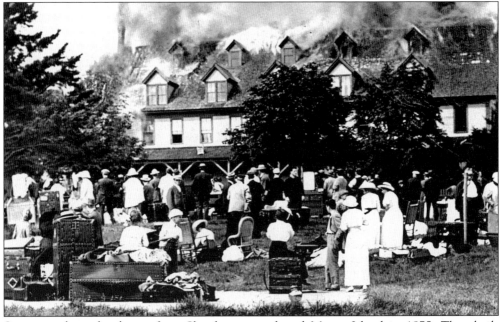

Summer colony developers from Skowhegan purchased Mouse Island in 1875. They built Samoset House in 1877 to complement the budding summer colony. Like the Menawarmet, Samoset House burned in 1913, but evidently the guests had plenty of time to escape. For many years, the island was the summer home of the late Rev. Harry Emerson Fosdick, a nationally known theologian.

The Lawnmere Inn on Southport (left), formerly the Rendezvous, and the Ocean Point Inn (below), formerly the Pleasant View House, celebrated their 100th anniversaries as summer hotels in 1997 and 1998, respectively. Unlike many of their contemporaries, they were not destroyed by fire and were not razed to make way for other commercial development. They, together with many hotels of more recent vintage, continue to thrive, carrying on the Boothbay region's nearly 135-year history of catering to the summer trade.

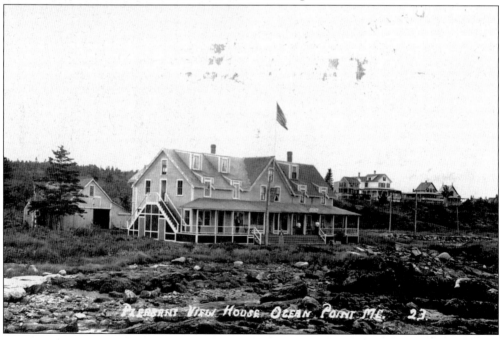

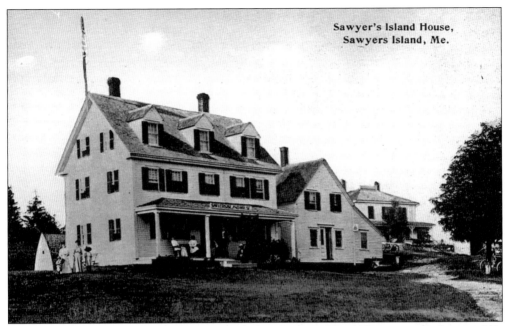

Built as a private home in 1846 by Zina Hodgdon, Sawyers Island House operated as a public resort for about 20 guests from 1879 to 1935. It was one of only two such resorts on the Sheepscot River side of the peninsula. The house was located near the current Isle of Springs dock, which formerly was a steamboat landing. Sawyers Island House burned in 1964.

In 1924, Joshua L. Brooks bought the Newagen House, run by Courtland Wilson, on the tip of Southport. Brooks remodeled and enlarged the boardinghouse into the Newagen Inn, which has been in continuous operation as a summer resort since then, despite a 1943 fire. The 64 people assembled here were members of the inn's staff during one of its first summers.

Summer colonies relied on local men to prepare their developments. For many summers in the 1920s, contractor Milton Giles, who specialized in earthmoving, foundation work, and house moving, worked on Pratt's Island, cutting wood, laying out roads, blasting, and building the bridge. Here, he and his horse, Old Bill, who pastured there all summer, grade sites for future cottages.

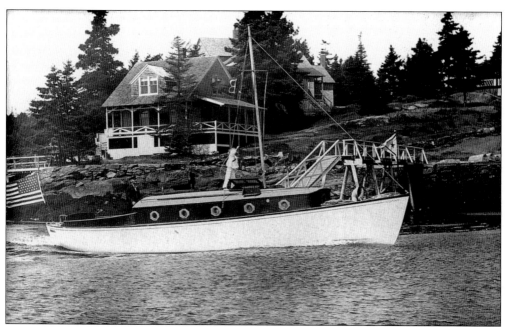

The colonies were generally located on scenic but rough, rocky, and vacant land unsuitable for permanent homesteads. Developers sold lots, which were often surprisingly small, to summer families. This 1920s photograph shows portions of three such lots, with each cottage sited to capture an ocean view. The house on the shore seems to have it all: an uninterrupted view, a sturdy dock, and a fine boat ready for an afternoon sail.

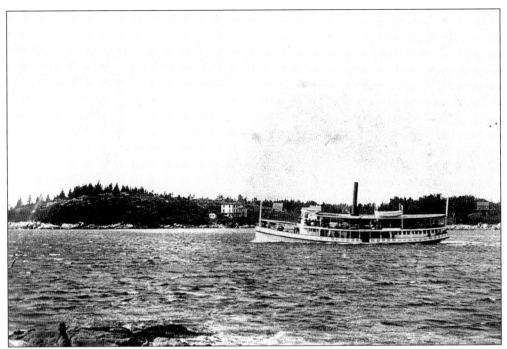

Juniper Point is largely empty in 1892, with the Bath steamer about to pass the Welch cottage, the first summer place built there. By the late 1920s, 15 cottages were scattered along the shoreline, with most of the construction having occurred in just a 20-year span. Today, just one more cottage occupies this site, but the trees are more numerous and much larger.

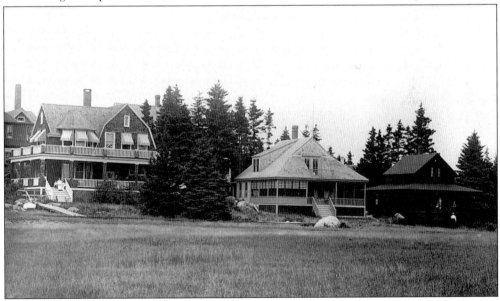

Every summer colony had numerous similar cottages, as the same builder constructed many cottages in each area. Maine styles, seen here on Squirrel Island c. 1915, differed from the traditional northern New England farm design. Some featured the Shingle-style Arts and Crafts look; others used "novelty" siding; still others were log cabins. Cottage interior walls were usually completely unfinished, with the framing and exterior wall boards visible.

What better way to spend a glorious summer afternoon than by enjoying a boat ride and a picnic on one of the region's beautiful islands? Here, in a photograph taken about 100 years ago, a group of picnickers is perched on the rocky shore of Fisherman's Island, which, together with the White Islands and the Hypocrites, marks the easterly entrance to Boothbay Harbor.

"Sometimes too hot the eye of heaven shines." The Spring House on Capitol Island and the surrounding whispering woods provided cool shade and a peaceful place to stroll for the summer visitors in the c. 1915 photograph.

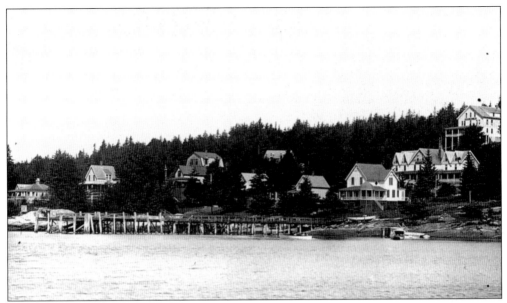

The steamer wharf at Murray Hill's summer colony in East Boothbay, pictured c. 1900, led ashore to classic summer cottages and two rooming houses. The many-gabled building was the Forest House, now the Five Gables Inn; it has been an inn continuously since it was built. Above the Forest House was the Murray Hill Inn.

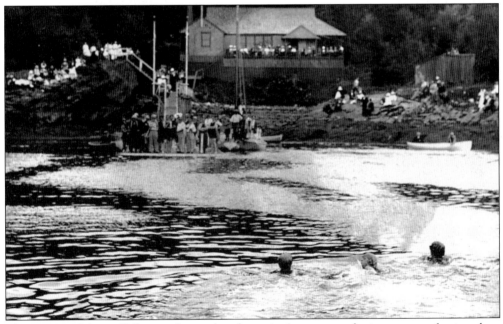

The casino at Murray Hill, one of several in the region's summer colonies, was a gathering place for social activities and sporting events. Located at the end of Murray Hill Road on Linekin Bay, it was built in 1904 and also served Bayville residents' recreational activities and religious services. No longer in use by the 1950s, it was eventually replaced by a summer home.

Not all summer colonies experienced immediate success. Between 1926 and 1928, developers built roads, trails, a headquarters, a bridge, a dammed 15-acre swimming area, and this observation tower to attract buyers to Little River, a scenic spot on the east side of Linekin Neck and the Damariscotta River. The development, named Boothbay Shores, failed during the Depression, but eventually thrived.

The Ocean Point Casino, built in 1905, was the summer colony's center of community life for nearly 70 years. Dances, theatricals, fairs, pancake breakfasts, and coffee socials took place here, as well as the annual meetings of the Ocean Point Association, now the Ocean Point Colony Trust. The casino burned in 1974, but its replacement continues to be the hub of Ocean Point activities.

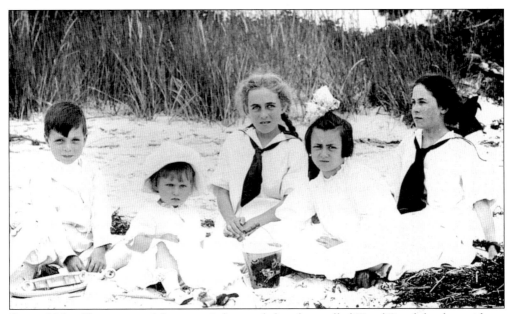

Squirrel Island boasts one of the region's few sandy beaches, called Hotel Beach by the residents because of its proximity to the former Squirrel Inn, which burned in 1962. These "Squirrels" appear ambivalent about being photographed. They look ready to enjoy the afternoon, although, judging by their clothing, swimming is not on the agenda.

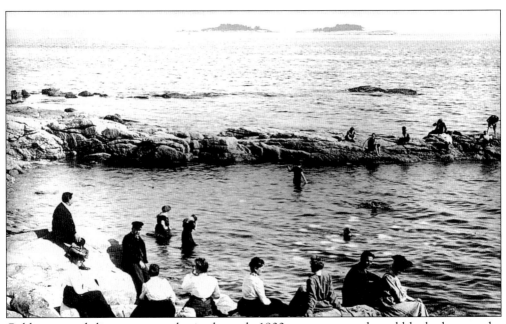

Cold water and slippery, wet rocks, in the early 1900s as now, caused would-be bathers on the Shore Road at Ocean Point to think twice before diving in. The ratio of swimmers to onlookers in midsummer remains about the same. The White Islands appear in the background.

Black servicemen were stationed at Ocean Point to watch for hostile vessels during the 1898 Spanish-American War. Their encampments were in the vicinity of Grimes Avenue. One of the veterans, William J. Williams, bought a place near the campsite and built a house *c.* 1903. Probably at Williams's urging, many veterans returned for reunions at Ocean Point, camping in tents near the shore.

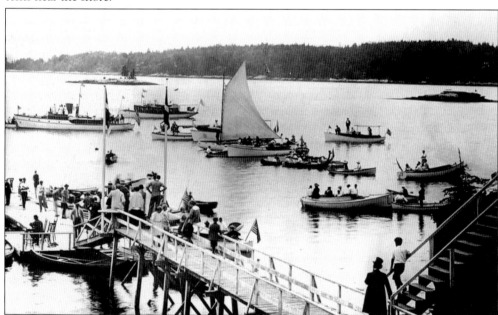

Bayville is one of the region's oldest summer colonies, its beginnings dating to the 1870s. It had about 36 cottages by 1906, as well as a community building, or casino, shared with Murray Hill. Boardinghouses and the Bayville Inn were built early in the 20th century, though now only private homes remain. Boating on Linekin Bay was popular, as shown in this photograph of the busy dock area.

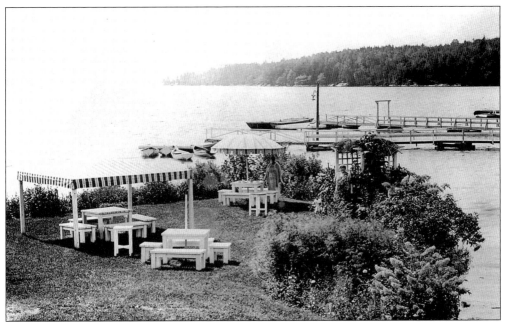

For decades, the summer colony of Bayville featured an outdoor tearoom on the shore of Linekin Bay. Here, in the 1920s, two women—either guests or hostesses—are almost hidden by the luxuriant flowering bushes and arbor, which must have added color and fragrance to the already pleasant and scenic setting.

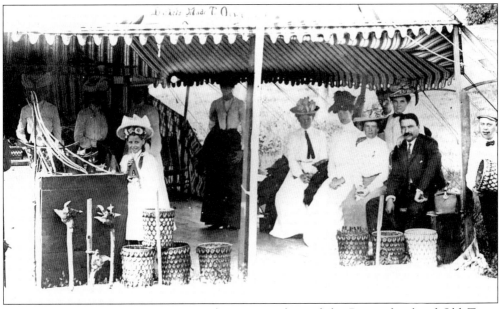

During the summers between 1902 and 1941, members of the Ranco family of Old Town maintained a place on Squirrel Island to sell their American Indian baskets, moccasins, and souvenirs such as the "war clubs" on the left, made from alder roots. They sold their wares in this tent until c. 1922, when they erected a shop. Family members still come to Squirrel Island.

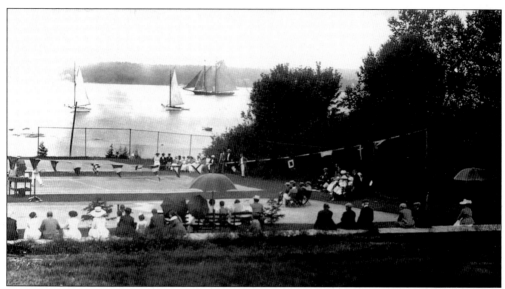

Tennis has flourished on Squirrel Island since at least 1886, when the first tournament was held. In the late 1950s, the island hosted the U.S. Lawn Tennis Association's Northern New England Championship tournaments. Currently, there are five courts. A resident tennis director arranges lessons, tournaments, and matches between Squirrel's young people and those of other local summer colonies.

While the summer scene may have been a round of daily recreational events—swimming, boating, and picnics—the remoteness of the summer colonies did not prevent exotic forms of entertainment. Here, an organ grinder and his monkey delight a crowd of Squirrel Islanders c. 1915.

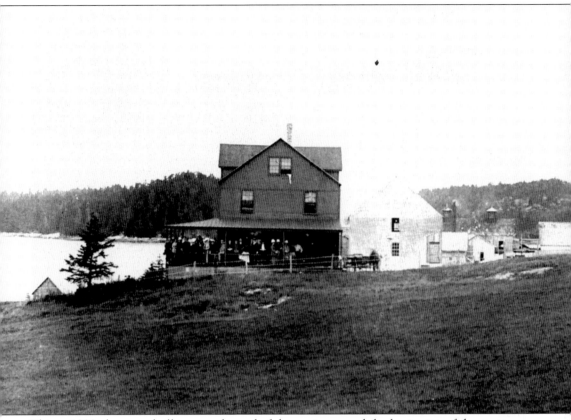

This c. 1890 photograph illustrates the end of the pogie era and the beginning of the summer-residency era on Linekin Neck. In the background is the Suffolk Oil Company, an 1866 pogie factory that survived as a lobster cannery. By 1890, it had been acquired by developers, and the land had been divided into summer-home parcels. The Wilde family bought an idle pogie factory site next door in 1883 and developed it into Mt. Pleasant, a three-building summer boardinghouse (one building is seen here) that held 50 people. One promotional piece stated, "Opportunities are offered for boating, fishing, sailing, riding, bathing and tennis, while stores and post office are within a few minutes' walk." By the second decade of the 20th century, Mt. Pleasant had evolved into a private family compound, now occupied by the fifth generation of Wilde summer residents.

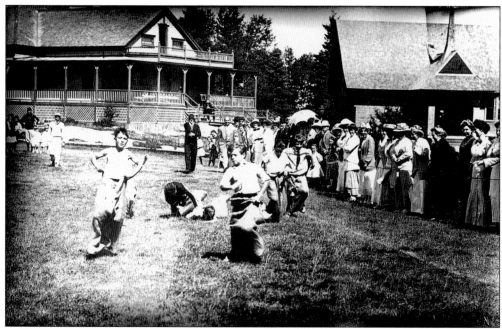

Summer colonies have developed annual communal traditions, many of them involving lighthearted competitions and foolishness. Above, Squirrel Island boys, c. 1915, compete with varying degrees of success in a sack race—much to the amusement of onlookers, most of whom are women (perhaps their mothers and grandmothers). Below, Ocean Pointers gather in 2000 for the Horribles Parade, an annual feature at Ocean Point for more than 80 years. Following a New England custom of uncertain origin, people dress up in masks and outrageous costumes around the Fourth of July and parade along the Shore Road accompanied by a pickup brass band. The Ocean Point group includes three generations of the same family, as well as a few other aspiring musicians—all are, mercifully, unidentifiable.

*Eight*
# OUR VILLAGES

In the 1700s and up to the mid-1800s, stores were scattered all over the region, in locations we would now think unlikely. Until 1892, Boothbay was divided into as many as 22 school districts, with as many schools and almost as many highway districts. For a student to attend a school outside the district bounds, a town meeting warrant article was required. Residents identified strongly with their villages, which usually included the school and one or more stores, perhaps a post office, and a church or chapel. After the 1920s, gas-powered transport led to the gutting of these small communities, with the consolidation of schools and the closing of the small stores.

In 1900, Boothbay Harbor proper was the largest village in the region. The three next-largest villages were East Boothbay, Boothbay Center, and West Harbor, with schools, post offices, firehouses, churches, and multiple stores. Boothbay Center's very centrality caused its growth, while attractive businesses—East Boothbay's shipyards and fish businesses and West Harbor's marine railway, fish business, and ice works—gave the others their focus.

The next tier of villages, with schools, fewer stores, post offices, and a church, were Trevett and Linekin. Young residents of Trevett, which included Barters Island, Sawyers Island, Hodgdons Island, and Knickerbocker, attended the two schools on Barters Island and the one on Sawyers Island. Those islands had strong fish-related businesses in the mid-1800s, which led to the presence of stores. All the smaller villages had varying features, but they always had a school, and almost all had a store at some time in their history. In northern Boothbay, those villages were Back River, Dover, North Boothbay (River Road), and Back Narrows.

Some seasonal communities after 1880 had post offices, and some, such as Ocean Point, Bayville, and Southport's many resort islands, had chapels. There were oddities: Dover is the only part of town without a recorded store in the last 250 years; Mill Cove was an entity in itself between Boothbay Harbor and West Harbor, commercially developed in various ways since the 1750s but without a school; the south end of Barters Island, Kimballtown, was a thriving commercial location for many decades.

Perhaps any 1900 resident asked to construct a regional village map would end up with a unique version. Principally, the school-district bounds governed perceptions of the villages' boundaries.

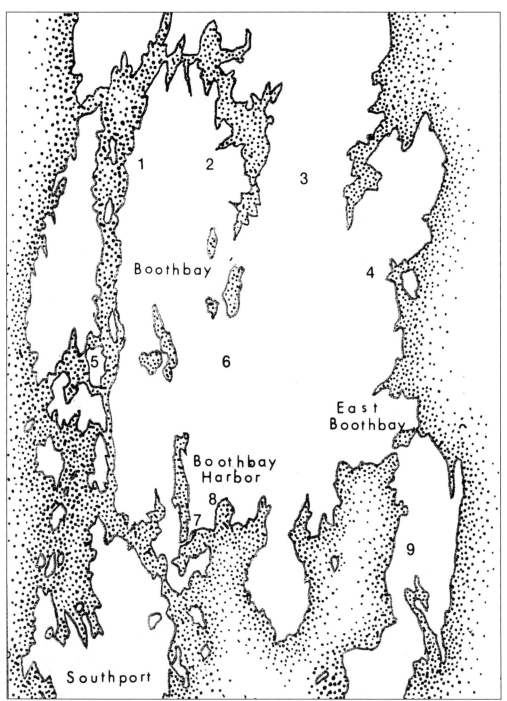

This Boothbay region map, drawn by Alden Stickney, shows the major centers of Boothbay Harbor, East Boothbay, and these other sections: Back River (1), Dover (2), North Boothbay (3), Back Narrows (4), Trevett (5), Boothbay Center (6), West Harbor (7), Mill Cove (8), and Linekin (9).

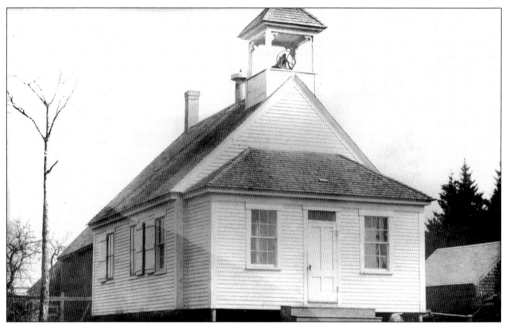

In the 1700s, Back River and Barters Island constituted School District No. 2. Slowly, they parted ways as the population grew, and Back River ended up as School District No. 24. In 1825, Back River built a school, perhaps the one seen in this c. 1910 photograph; before that time, school was probably held in a room in a local house. The Back River School closed in 1944 and is now a private home.

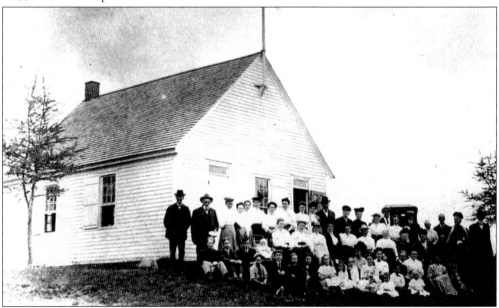

The Dover School, District No. 15, is the site of this school reunion before 1913. Included in the photograph are eight Welshes, one Tibbetts, three Lewises, two Pages, one Dodge, and one Kelley. Some of the older former students had attended the first Dover school, which burned. A 1907 reunion attracted 125 people. The school closed in 1920 and was moved to Southport, where it is currently a residence.

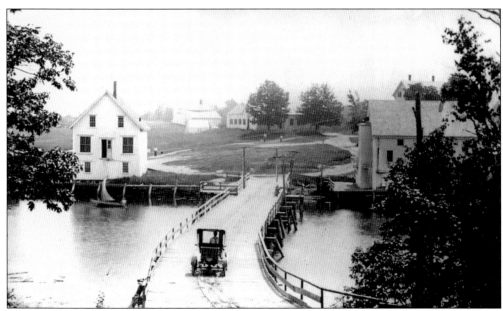

The Hodgdons Island building on the right in this c. 1915 photograph was "the hall," a Hodgdon family storage facility and community gathering place. The S. G. Hodgdon store, seen on the left, was built in the mid-1860s after an earlier store had burned. The family maintained a store in that location for about 140 years. Still a store and post office, it is now owned outside of the family.

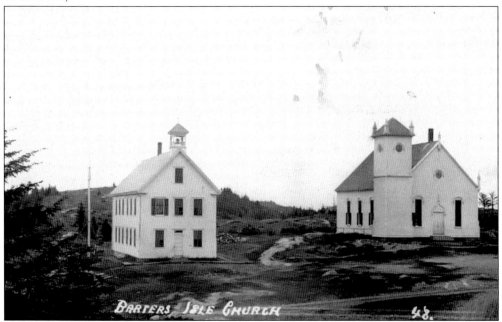

In 1892, carpenters Paul and George Giles replaced the old Trevett school with this new two-story schoolhouse on the lower end of Barters Island. While the Trevett School covered all grades, including a two-year high school, after 1933 the older students were bussed to Boothbay Center. The school finally closed in 1957. The Baptist church, next to the school, was dedicated in 1876.

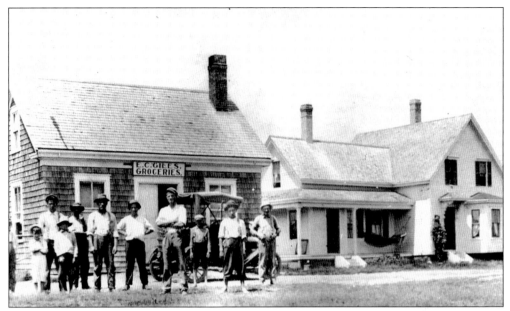

The neighborhood store was usually the congregating place for area men. Edson Giles appears here on the far right by his store at Back Narrows, which he opened in 1904 on Camps Hill when the Huff store closed. In 1914, Edson's son Ralph came to help with the business. The men sold all kinds of goods, including their own milk and homegrown vegetables. The store shut in 1925.

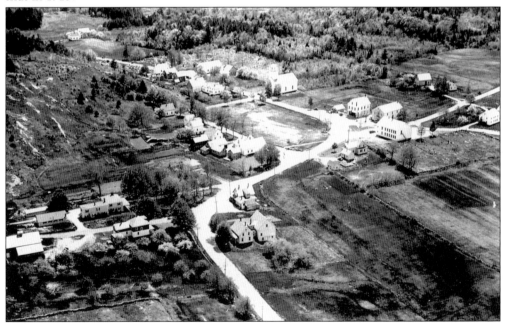

In 1940, Boothbay Center was fairly taken up with commercial and community buildings around the surviving part of the common. The town hall, fire station, garage, parsonage, and Baptist church are seen at the left and south, the lower, far end of the common. The school, the Grange hall, Welsh's post office and store, and the Adams Inn Restaurant are at or near the upper end. Chapel Street was not yet created.

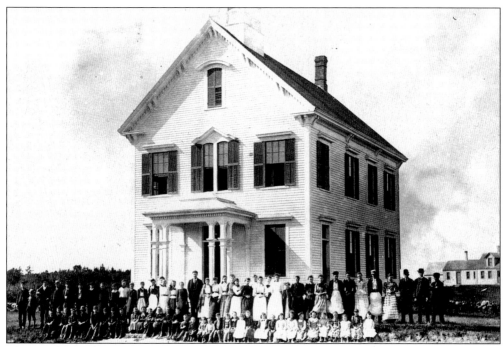

The Boothbay Center School, seen here c. 1890, was built in 1877, replacing an earlier school that was moved across the common. The 1877 school, discontinued in 1912, was bought by Byron Giles for storage, and the top floor served as the Grange hall until the late 1920s. Later, it was remodeled into a garage; it was torn down c. 1990. The town office now occupies its site.

Boothbay's first church was moved off this Boothbay Center site in 1848, and the second church, seen here c. 1900, was then built. In 1912, it was remodeled into a school. Vacant in the 1970s, it burned in 1981. Behind the 1879 Civil War monument is the 1768 Nicholas Knight house. John Murray operated the house as an inn from 1780 to 1798. Nicholas Knight acquired it in 1804.

David Kenniston moved to Boothbay Center in 1796 and built this house the next year. In 1798, he started inn keeping after the nearby Murrays discontinued their inn. Kenniston continued his inn business intermittently in the early 1800s. The house was then a private home for about 150 years, except for a 1920s interlude when it was the golf course clubhouse. For the last few years, it has been a bed and breakfast.

The Teel family children, who lived in the Kenniston house at Boothbay Center, evidently ran out of dolls to dress, so they dressed their cat. Shown here in the 1920s is the family pet taking its ease in a rocker by the old cooking fireplace at the Kenniston-Teel house. The Teels ran the nearby golf course from the 1920s to the 1950s.

From the mid-1700s to the mid-1900s, various stores operated at West Harbor. The Orne store, located below Orne's Hill near a stone wharf, was a presence from c. 1845 to 1950 and served as the post office after 1882. Silas and Thomas Orne started the business, which closed at the death of Thomas's grandson Charles Orne. Summer resident Mr. Noe smiles for the camera c. 1920.

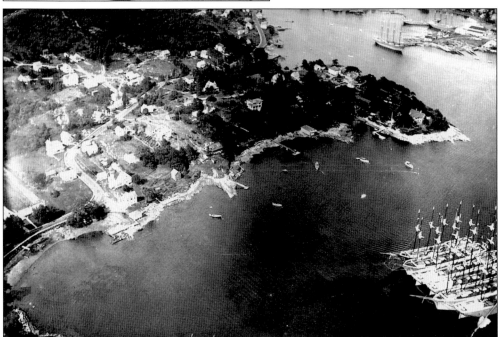

This c. 1930 aerial view of West Harbor and Mill Cove shows laid-up coasting schooners awaiting their fate. The discontinued community buildings clustered at the upper left include, from left to right, School No. 17, built in 1883 and closed in 1960; the chapel, built c. 1905 and closed c. 1949; and the fire station, built in 1915 and closed in 1930. The school is now the Lions Club.

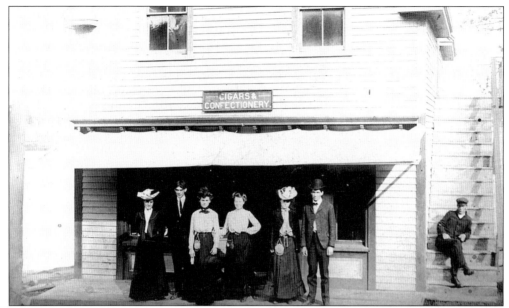

Ordinarily, there was a store at Mill Cove. This 1903 photograph shows Keene Barter's first store, which complemented his little sardine factory. It later became Farmer's Swimming Pool; there is now a home on the site. Pictured, from left to right, are Ida Adams, Arthur Barter, Emma Davis, Edna Bowman, Mae Abbott, and unidentified. Ed Williams sits on the stairs. The store, moved in 1905, became a home on Sea Street across the cove.

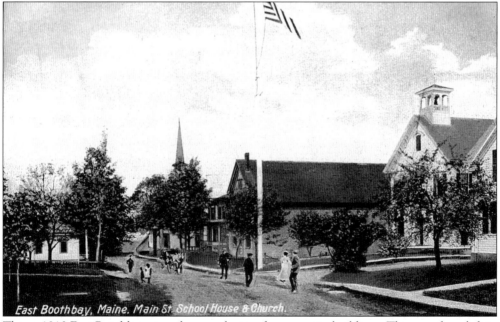

This c. 1910 East Boothbay view shows a cluster of community buildings. They are, from left to right, as follows: the Boothbay Medicinal Mineral Spring (nearly obscured by trees); the Methodist church, erected in the 1830s a half-mile away and moved here in 1863; the 1863 Independence Hall, erected for the Grand Army of the Republic but used for all occasions; and the 1876 school. The school flag flies, as mandated by a 1907 law.

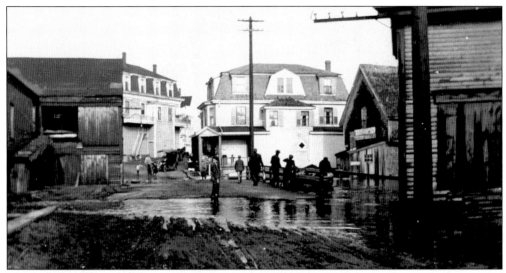

The bridge at the heart of East Boothbay is awash during a 1920s high tide. In the foreground is the fish market; behind is Hodgdon's stable and the 1886 mansard-roofed stores. J. R. McDougall's is on the left, behind the tide mill, and A. O. McDougall's is on the right. Both the mill and J. R. McDougall's store were torn down—the mill in 1959, the store in 1944.

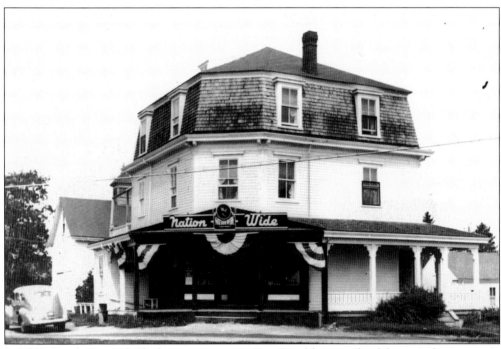

In 1890, Frank Seavey built the corner store in East Boothbay, south of the main business area and above the school. Seen here c. 1950, the store lost customers with the rise of supermarkets and the ease of travel; the customer base fell to 30 percent. Today, it continues to function partially as a general store, though oriented more to snack food since the 1960s.

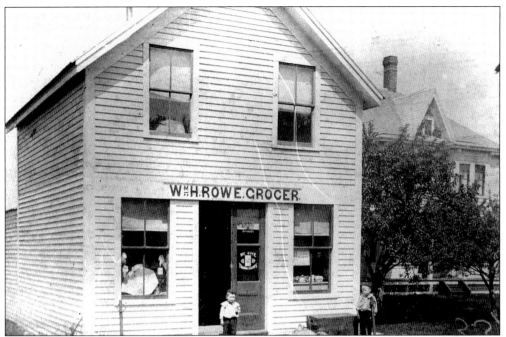

There were multiple stores at Linekin up to the early 1900s. The Rowe store was one of the smaller ones and was less than a quarter-mile from the larger Holbrook store to the north and from the Ephraim Linekin store to the south. The Rowes were Holbrook relatives; storekeeper Maggie Rowe was called "Miss Tappytoes" for her habit of tapping her shoes while seated.

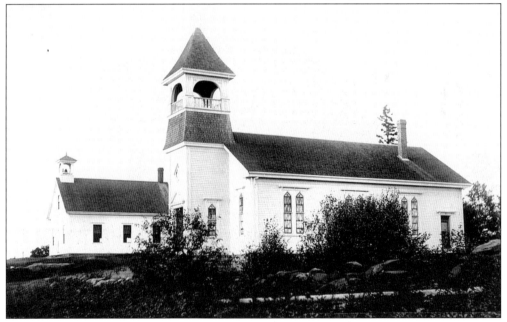

The Linekin Methodist Chapel, built in 1913, was discontinued in 1936 and was vacant for many years. In 1944, it was converted into a house, and it is now a gift shop. The first Linekin school was built in 1805 by a Holbrook; seen here is the third, built c. 1899. Also in 1936, the Linekin School was closed, and local children were bussed to East Boothbay.

Albert Barlow of Barlows Hill, East Boothbay, takes a long, pensive look across the water from a fish wharf. When not teaching industrial arts at the local high school, he fished for herring and tended some lobster traps. Barlow built boats when they were needed by the family; he built at least one 42-foot fishing boat and two lobster boats. His constant companions outside the classroom were his cap, pipe, hip boots, and navy watch jacket, a jacket he got in the U.S. Navy during World War II and which he wore nearly until he died decades later. Seen here c. 1955, Al, with his multiple jobs and simple lifestyle, personified the standards of premodern life in a small, peaceful coastal village. (Courtesy of Bill Barlow.)